For Jill & Tom —
A pleasure sailing with you
in Alaska,

— Kim Heacox

July 19 2001
Happy 35th Anniversary

W9-BTJ-534

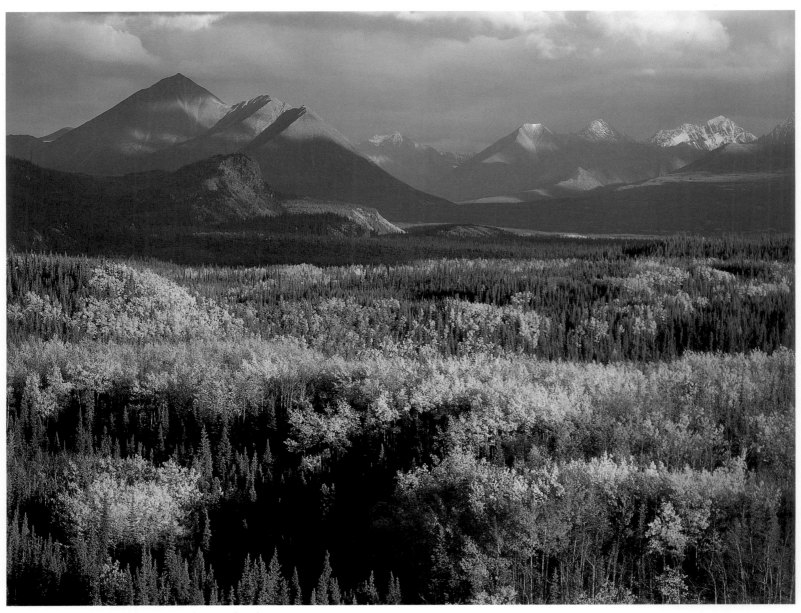

Autumn colors in Riley Creek drainage, Denali National Park

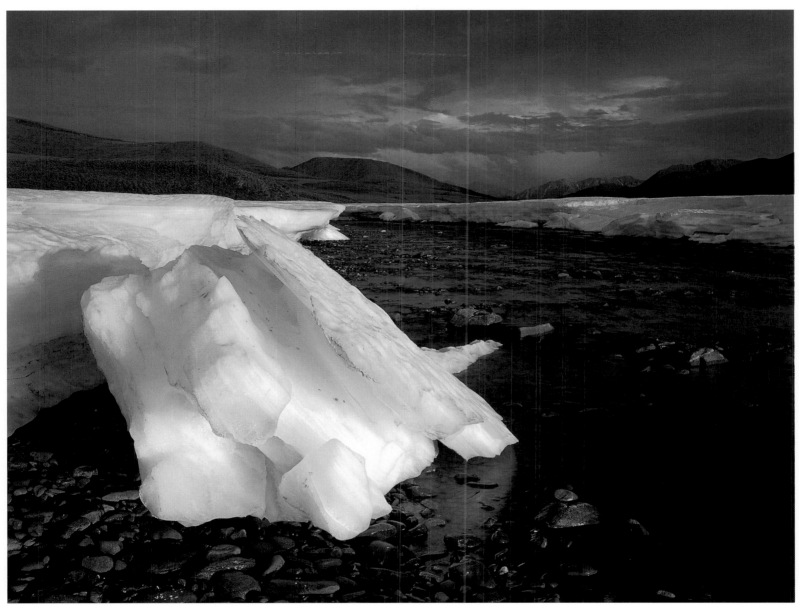

River ice (aufeis) on the Kongakut River, Arctic National Wildlife Refuge

3

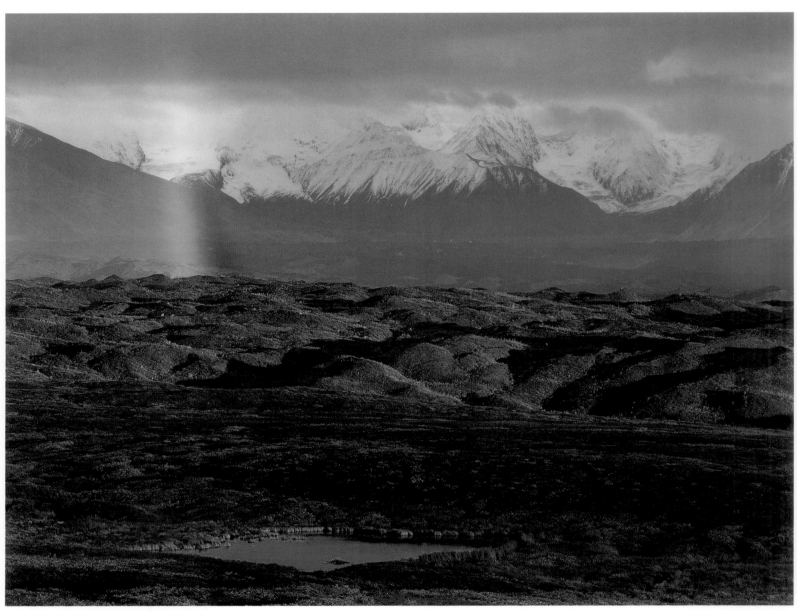

Rainbow over a kettle pond and the tundra-covered terminus of Muldrow Glacier, Denali National Park
Opposite: Bull moose in Wonder Lake, Denali National Park

Alaska Light

IDEAS AND IMAGES FROM A NORTHERN LAND

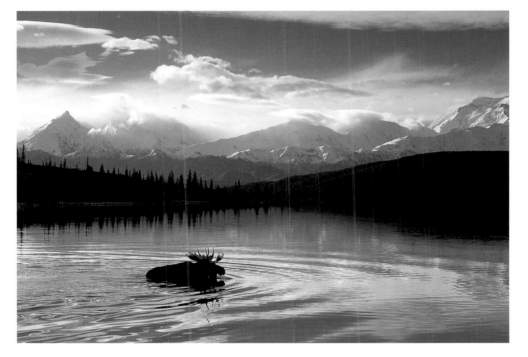

ESSAYS & PHOTOGRAPHS BY

Kim Heacox

COMPANION PRESS
Santa Barbara, California

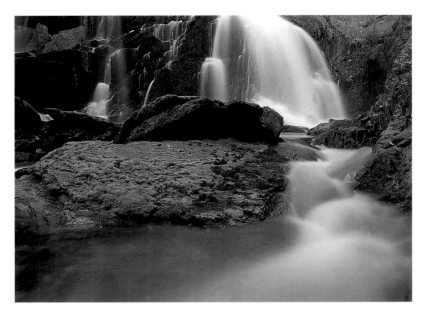

Companion Press
Bishop, California
Jane Freeburg, Publisher/Editor
Mark Schlenz, Consulting Editor
Designed by Lucy Brown

Essays, captions, and photography by Kim Heacox.
Additional photography by Kathy Bushue (97, 102)
and Ken Graham (23, 46-47). Used with permission.

All photographs in *Alaska Light* are available for
editorial, commercial, and/or advertising use from:
ACCENT ALASKA/KEN GRAHAM AGENCY
Anchorage (907) 561-5531
Girdwood (907) 783-2796

www.accentalaska.com

Printed in Hong Kong
through Bolton Associates,
San Rafael, California

ISBN 0-944197-55-8

Third Printing, 2004

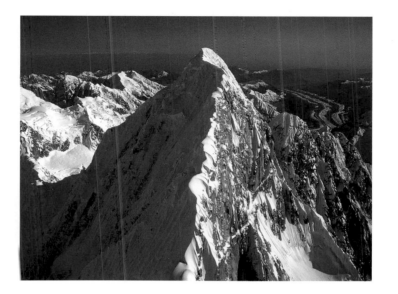

In Memory

Michio Hoshino ❦ Dugald Bremner
1952–1996 1955–1997

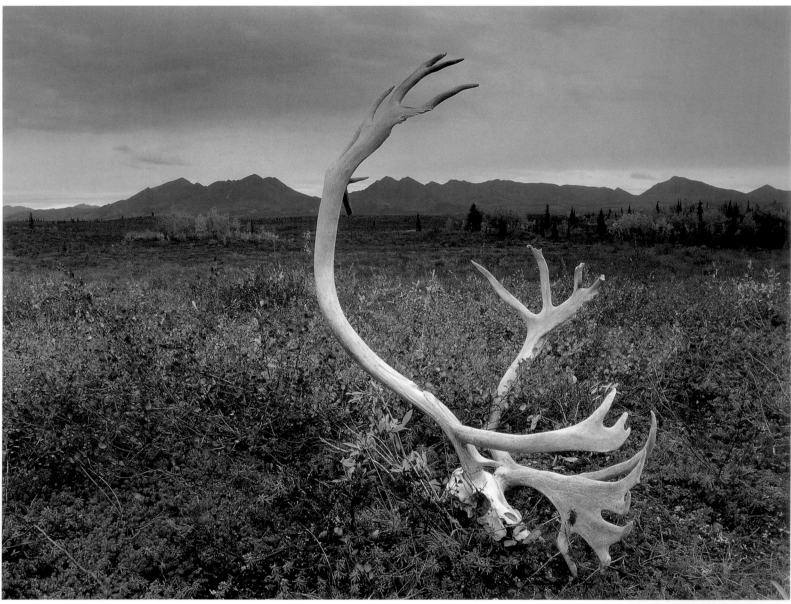

Caribou antlers, Onion Portage, Kobuk Valley National Park
Opposite: Douglas Island, Juneau

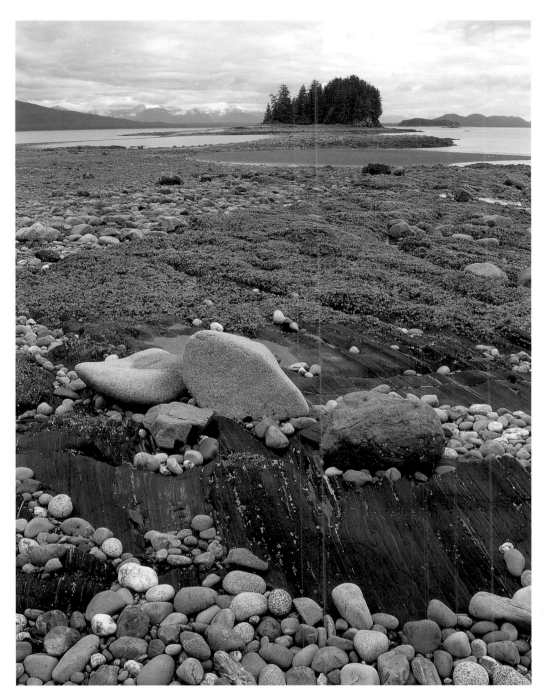

Contents

Alaska Light 11

Wisdom of the Winter Wren 25

Only in Alaska 51

Frontier Rhetoric 75

Caribou Dreams 91

Lineages and Legacies 106

Photographer's notes 112

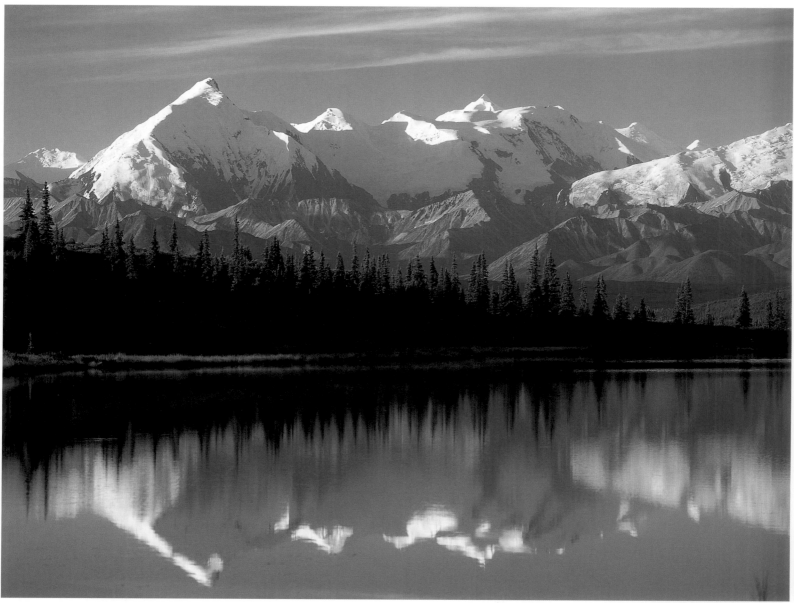

Mt. Brooks and the Alaska Range from Wonder Lake, Denali National Park

Alaska Light

Alaska light, like Alaska itself, is rich with extremes. The sun dances and disappears, dances and disappears. It paints a broad brush stroke, brilliant at times, subdued at others. And while guaranteed to bring the seasons and take them away, to illuminate a grand geography of mountain, tundra and fjord, to spotlight grizzly, caribou and whale, light in Alaska is not taken for granted. It is prized, celebrated, honored. It gives life and takes it away. It deeply affects Alaskans who wake and sleep to its rhythms, who drink light like ambrosia—nectar of the gods.

North light in a forest unveils a hundred inventions of green. South light in winter paints cold pinks on icy peaks. East light brings morning promise, and west light, in summer, a lingering warmth that once again seduces Alaskans into saying: Okay, one more year. I'll live here one more year, one more winter, then move to Baja or Tahiti or Sri Lanka. Humorist Tom Bodett says: We don't intend to stay here, we just come up for a summer and "forget to leave." Next thing we know, we've been here thirty years.

Other Alaskans have no doubts. There is no other place for them. They don't need to snorkel in Pago Pago. They get out by skiff, ski and sled dog team and explore the only place they need to know. They wrap the geography around them like a blanket, a blanket of infinite texture and tone, all defined by light. They sleep ten hours a day in winter, five in summer. They know where they want their ashes to go: a favorite mountain, a bend in a river, a bay where mergansers gather in the spring, and geese in the fall.

Alaska is ruled by the bold presence and stark absence of light. The sun doesn't rise or set perpendicular to the horizon (that only happens on or near the equator, between the Tropics of Cancer and Capricorn). Here the sun is playful. It hides for months, peeks out, rolls into a graceful zenith, descends

at shallow degrees, bathes the land in rich pastels, then winks away again. A single Arctic sunset and sunrise, bridged together on a magical summer night, can last hours. Children in Barrow play softball until 4:00 A.M. River rafters eat dinner at midnight, go for a hike and finally bed down at six, long after the sun has dipped—not set—to the north, kissed the horizon, and begun its ritual climb to the south.

Winter is another story. The sun goes down in Barrow on November 18 and doesn't rise again until January 23. People there talk about "going into the tunnel." On December 21, the winter solstice, Juneau receives only 6 hours, 21 minutes of daylight; Anchorage 5 hours, 23 minutes; Fairbanks 3 hours, 42 minutes. The winter air in Fairbanks is so cold, airplanes pop into the sky on takeoff, firewood snaps apart at the strike of an axe, vehicles run all night in parking lots and driveways.

Then comes summer, redemption, when everything bursts to life. The land itself seems to grow, to uncurl from its own long sleep, to awaken and stretch. For a moment, perhaps longer, the light makes children of Alaskans who are otherwise automated by commerce and calendars. It snaps them into rhythms ancient and nearly forgotten; a time, long ago, when every human lived in close reciprocity with the earth, to the air and water, seals and song-birds, snow and silence. When people forecasted weather by the timbre in a twig, or understood their own prosperity in the call of an owl. When gifts were received, not taken. When the forest was a community, not a commodity. When life was difficult, but in that difficulty emerged honor, love and truth.

Light is, after all, a form of energy. Even in the darkness of winter, Alaska celebrates with the northern lights, the aurora borealis, dancing and pulsing through Polaris, Cassiopeia and Ursus Arctos, the great bear, the Big Dipper. In Valdez, people claim the sun sets five times a day in winter, as it swings low to the south and slices through a row of peaks like Orca's teeth, emerging and hiding five successive times before winking away.

Playwright Thorton Wilder asked, "For what human ill does not dawn seem to be an alleviation?" In Alaska, it is still morning in America. Light still spills over an unbridled land. How long will it remain so, at present rates of forest cutting, road building, mining, drilling, buying, selling? Frontiers never last. I suspect the future of Alaska, even the future of the earth and ourselves, will be a measure of our own self-imposed restraints more than our freedoms. A man can get more easily drunk on freedom than he can get sober on restraint. As can a woman. Anyone. For myself, I prefer not to photograph wolves or ravens. It doesn't seem right. It's their eyes, and everything else. I fix my lens on a wild animal and ask, "For whose honor am I taking this picture, yours or mine?"

My first time into a new place, I try to walk about, paddle my kayak, or sit in the woods and look and listen without my cameras and lenses and filters and film and tripod and blah, blah, blah. It gets easier as I get older. I blame my heavy pack and my aging knees. But to be honest, I like the peace. Without my cameras, I move more patiently. I demand less of the earth and myself. I don't curse the wind or second-guess a shutter speed. "Seen anything?" a man once asked me in Denali National Park. It was 11:00 P.M. in late June, with rose light in the valleys, scalloped clouds overhead, ambers and ochers anointing the peaks, and I thought to myself, yes, I've seen heaven on earth. So have you. But he was from Europe, and looking for wildlife, so I said, "Oh, you mean animals? No, not recently. But it's a beautiful night, don't you think?"

He smiled and said, "Yes it is, it really is." He sat on the tundra and said nothing more. Just sat there, legs crossed, watching morning in America. ❧

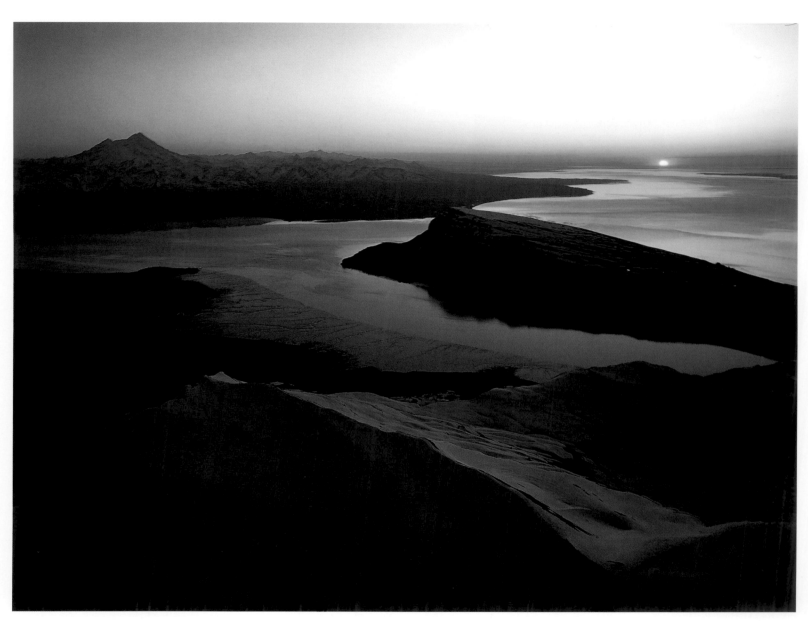

Sunrise over Cook Inlet, Tuxedni Bay, Chisik Island, and Redoubt Volcano (upper left), Lake Clark National Park

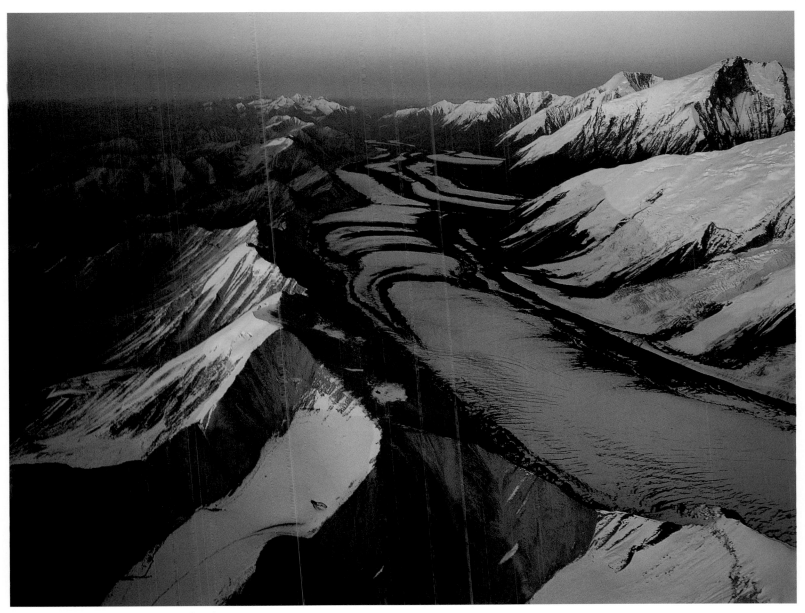

Sunset on Muldrow Glacier, Denali National Park

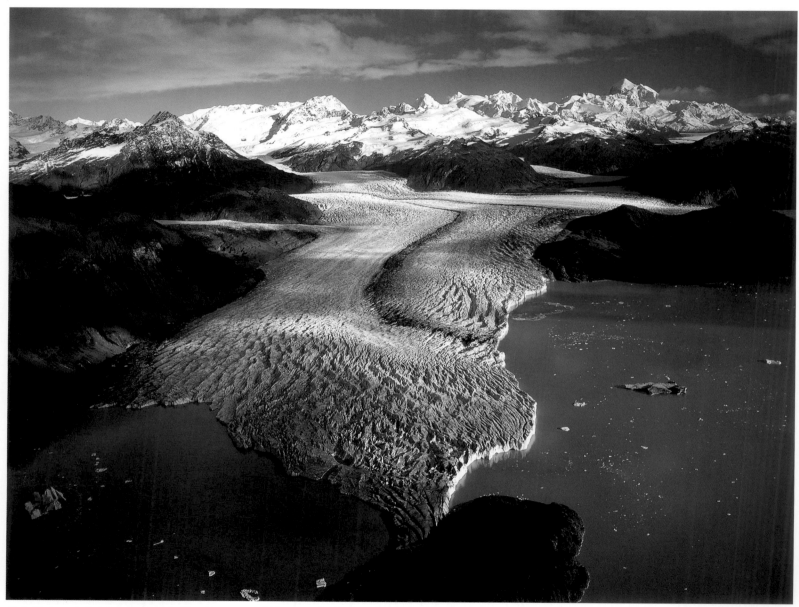

Alsek Glacier and Alsek Lake, with the St. Elias Mountains and Mount Fairweather beyond, Glacier Bay National Park

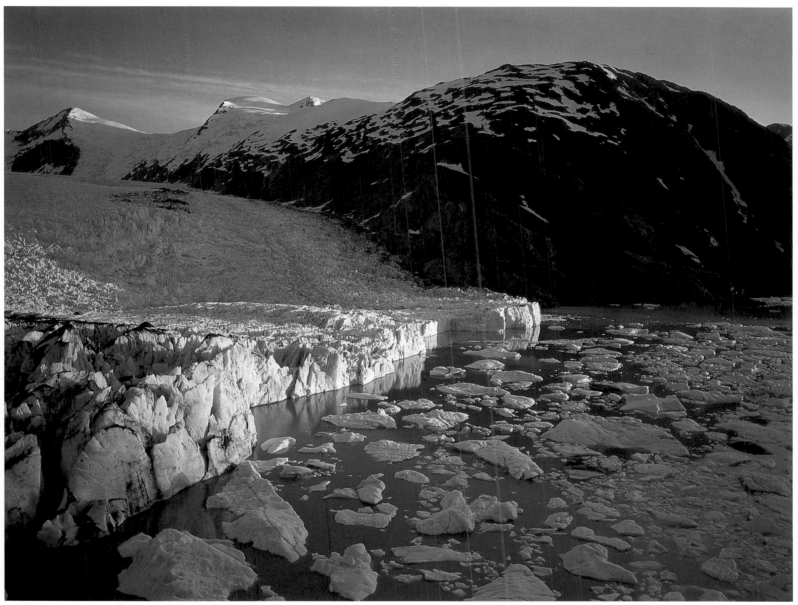

Portage Glacier and Portage Lake, Chugach National Forest

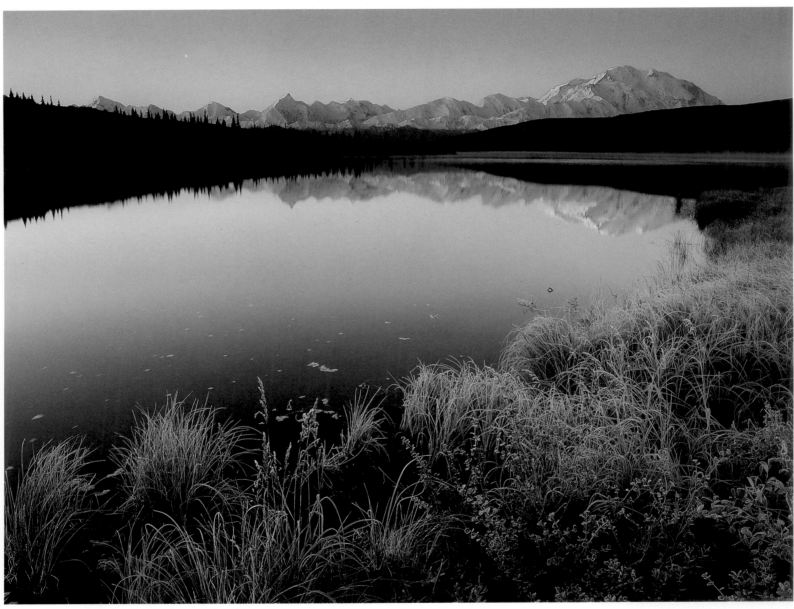

Mt. McKinley from Wonder Lake, Denali National Park

McKinley Mornings

From the north end of Wonder Lake, Mount McKinley rises 30 miles to the south (opposite), catching the first light of dawn and the last of dusk. At 20,320 feet, it is the highest mountain in North America. At 63°04' north latitude (238 statute air miles south of the Arctic Circle), it is one of the coldest mountains in the world outside Antarctica. Composed of granite and mantled year-round in ice and snow, McKinley is an Alaskan icon, the centerpiece of Denali National Park & Preserve. Seventeen major glaciers flow down it. From any angle it cuts an impressive profile, such as Pioneer Ridge (right), which separates upper Muldrow Glacier from the north-facing Wickersham Wall, a 14,000-foot near-vertical drop, one of the most famous mountaineering walls in the world.

Summer and autumn mornings find small numbers of grateful admirers who gather at Wonder Lake to watch dawn on the mountain. Grebes, ducks, and loons call. Sandhill cranes fly south, their prized music a magical borealis of life and celebration: another summer ended, another generation born. Bull caribou joust on the tundra in preparation for the coming rut. A moose might walk into the lake, wreathed in morning fog, and stay for awhile if people are silent and still.

Crowding will not work here. Add more and more people and the pristine crucible will crack and finally break. It has in fact already begun to crack under pressure from increased traffic and demands for more and better access and more accommodations from politicians and developers who know the cost of everything and the value of nothing. Yes, Denali National Park is big. So is Alaska. More people could fit into both. But what then? Rows of tundra toilets? Constant human chatter? Photo workshops with everybody taking the same picture in a different way? The first rule of progress is to NOT lose what we already have. In a fight to save wild places like this, every defeat is final, every victory provisional. A new hotel might not be built this year, but in the mind of the developer the hotel site is always there. Any treasure can be stolen.

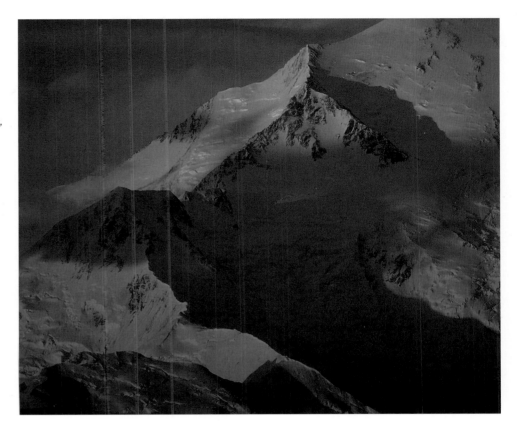

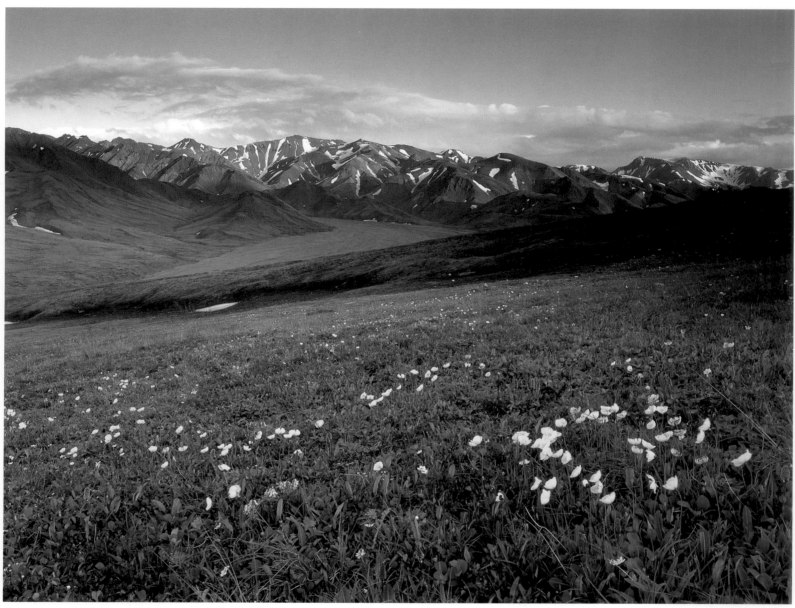

Arctic poppies and pink plumes, Highway Pass, Denali National Park

20

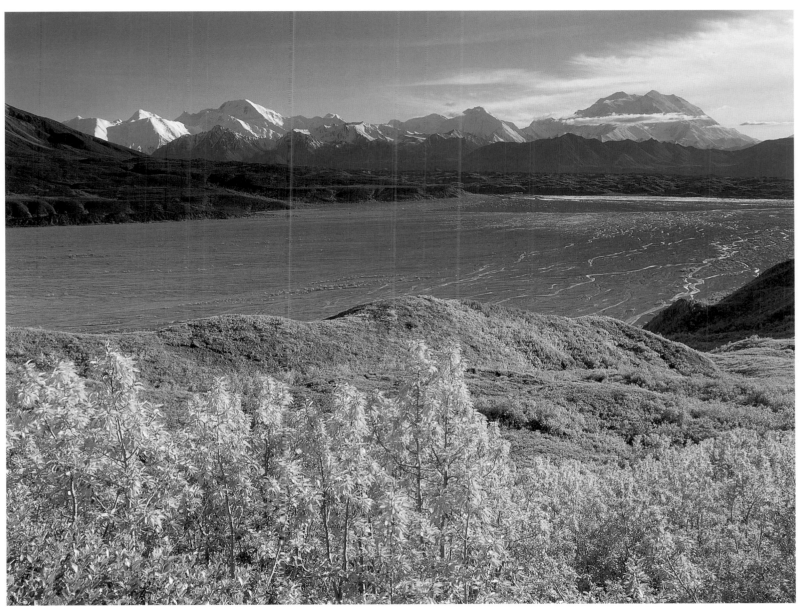

Autumn birches, Thorofare River, and Mt. McKinley, Denali National Park

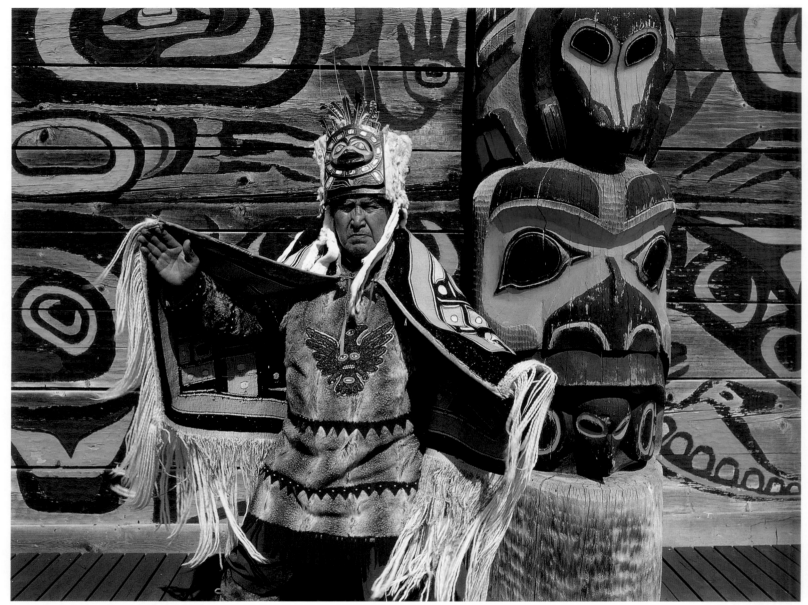

Chilkat dancer Charles Jimmie, Sr., Raven's Fort, Tlingit Tribal House, Haines

Northern Lights, Northern Lives

Alaska's winter darkness is compensated by the aurora borealis (northern lights) that dance in greens, whites, reds, purples and blues through the starry sky, sometimes streaking through the emblematic Big Dipper (right). The aurora is a complex physical and chemical phenomenon, created when charged electrons and protons are released by the sun during high sunspot activity. This solar wind is pulled into the earth's polar atmosphere by magnetic forces. The colors of the aurora vary, depending on how hard the charged particles hit the atmosphere.

Native peoples of Alaska didn't need science to explain this, however; they had magic and spirits and legends of how the forests and sea and sky were made. When Charles Jimmie, Sr. dances in his Chilkat Blanket and parka squirrel tunic, at Raven's Fort in Haines (opposite), he is an open book to his people's past. He reminds them who they are and where they came from. His heartbeat becomes a drumbeat. His arms become wings. His robust voice and ancient motions remind us that not so long ago all our learning was through story; that every day we breathed fresh air and drank clean water, and every night we slept on the cold, comforting earth, warmed by fire, family, and friends.

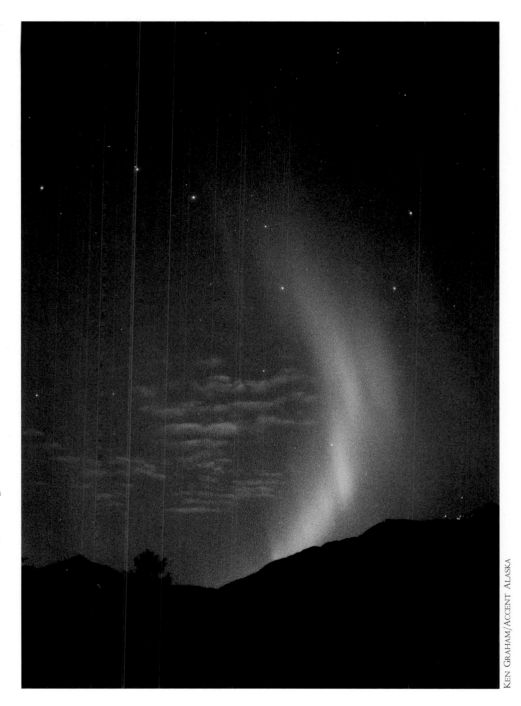

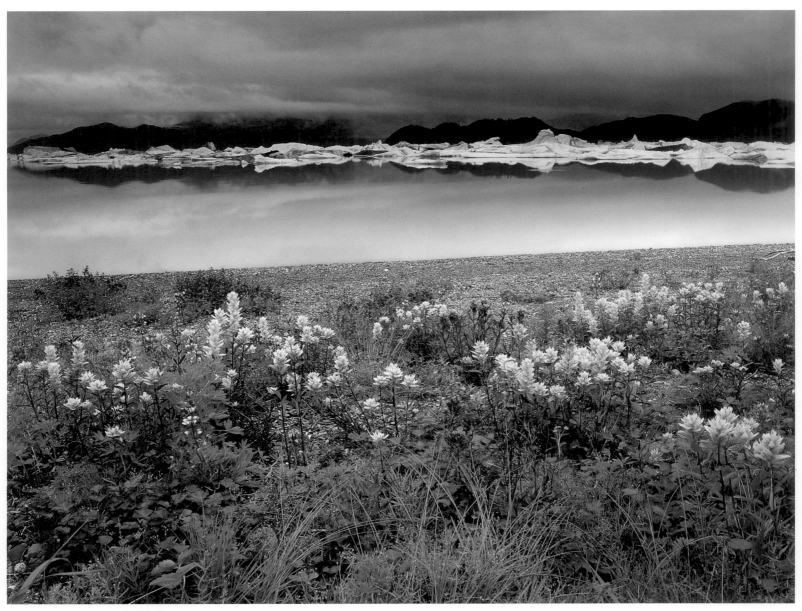

Yellow paintbrush, red dwarf fireweed, blue lupine, and icebergs, Russell Fiord Wilderness, Tongass National Forest

Wisdom of the Winter Wren

I sit on a rock by a cabin in a forest, where October storm waves slam on shore and a salt mist rises. Spokes of sunlight spill through brooding clouds and stab the sea like gleaming silver swords, their blades bold against the indigo storm. A motion catches my eye, something in the trees. I hear a soft "Chit, chit…chit, chit…chit, chit." Branches move nearby. This is no bear or wolf or whale, nothing fashionable to those who buy and sell Alaska in the tourist trade. This is a winter wren, what a friend of mine calls: a walnut with wings. An exquisite cinnamon-colored bird with an erect tail and dark eyes, and said to have a continuous call of more than 250 separate notes. So much music from a little singer. Four feet away now. I turn my head for a better view. It fits away.

I have come here to learn to breathe; to slow down, if possible. To mend and be mended. Because I live a busy life, and hide from the truth in my own business, I do not know what to do with myself. Not at first. No phone or fax or e-mail to set my clock and mark my day. No deadlines or kill fees or business hours. No hours at all. Just day and night, night and day, high tide, low tide, wind, rain, sea, storm. Stillness. A now-and-then glimpse of the sun, my favorite star. Warmth from a fire. Light from a candle. Water in a bucket from rain off the roof. Home-baked bread and hand-picked berries. Earthtime and other rhythms apart from me. Not knowing what to do confirms that I need to be here. I can learn patience from these rocks, and tenacity from the kelp anchored to them. How is it that out here, away from so many, I feel more human, and humane? I feel that I am a child again, on hands and knees to examine hailstones on the muskeg. This grand nursery called nature that raised my species and every other on earth, that gave us a vernacular and a vitality so sinuous and strong, how can we be so estranged?

By kayak, my friends and I explore a coast as wild as it was 256 years ago, in 1741, when Vitus Bering and Alexei Chirikof dropped anchor in two small packet boats to begin the European discovery of Alaska. The world's human population was increasing by about one million people per year back then. Today, it's increasing by one million people every 72 hours: a rate more than one hundred times faster. Amid this wildness, it seems odd that the world is so crowded; that across this ocean are people who live on top of each other, who sleep to the wail of police sirens, who jostle to work on crowded subways beneath concrete canyons.

My friends and I find an old plastic bottle, a piece of ragged fishing net, a rusty can. No other sign of man for miles. Not even lights from fishing boats at night, or freighters a few miles off shore, in the Gulf of Alaska. Everything else is wild: feathered forests, wave-sculpted shores, ravens in the wind.

We paddle through rough water—waves washing over the bows of our kayaks—until we round a headland and slip into a quiet bay. As the waters calm, so do we. Nine river otters play on shore, and freeze at our approach. We drift. The otters grunt, whistle, squeak with curiousity and fear, then bound upslope into the forest. A harbor seal surfaces, head half out of the water, obsidian eyes watchful, mistrusting. A loon calls, a magical borealis of music. A kingfisher ratchets on the wing. We say nothing. The voices around us would be unimproved by our own. Even when rafted together to share apples, cheese, nuts, and chocolate, we say little, and say it softly. Somebody mentions the tide is ebbing, we'd better get back to camp.

Back home, the radio says the stock market dropped 500 points. Oh yes, the stock market, I almost forgot. I almost forgot that people on Wall Street fill their lives with minutes. They buy and sell, and speak in sports metaphors —"hardball" and "full-court press"—and live behind bolted doors, and pay their therapists ten grand a year, and wonder why their kids are preoccupied by money.

My friends and I prefer the wisdom of the winter wren: an elegant, concise, sustainable economy dedicated to making a living, not a killing. We make our homes in Alaska; in a small town reachable only by boat or plane, population 350, not counting the moose and bears, where kids chop wood and study starfish and live one step removed from a product-driven world. We draw sustenance from the wild beauty around us; we are deeply wounded every time one of our representatives in Washington or Juneau writes a bill that will level a forest, poison a bay, allow oil drilling in a wildlife refuge, add noise and commercialism to a national park. These men play hardball and butter the bread of thousands of other Alaskans who see the world as they do. "Democratic nations," wrote Alexis de Tocqueville in the 1830s, "will habitually prefer the useful to the beautiful, and they will require that the beautiful should be useful."

Everything changes, is the mantra of modern man. Isn't that the best reason of all to keep Alaska wild? As the world sinks beneath concrete, commercialism, urbanism, and people, won't Alaska's value increase in proportion to its wildness and opportunities for solitude?

Chit...chit. The winter wren is back, balanced in its world as it has been for tens of thousand of years. It returns to the same branch again and again. "Do you think the wren ever dreams of a better house?" asked poet Mary Oliver. It comes nearer now, such a small thing in a big world. Is the purpose of the giant spruce to provide shelter for the tiny wren? Do I dream with my eyes open? Or are dreams, like better houses, not necessary here? Every moment is an awakening, day and night. I have forgotten my own hunger and old desires. I have listened to the sea and wind and forest and heard things I never knew were being said. Things said even now, when I cannot hear them. ❧

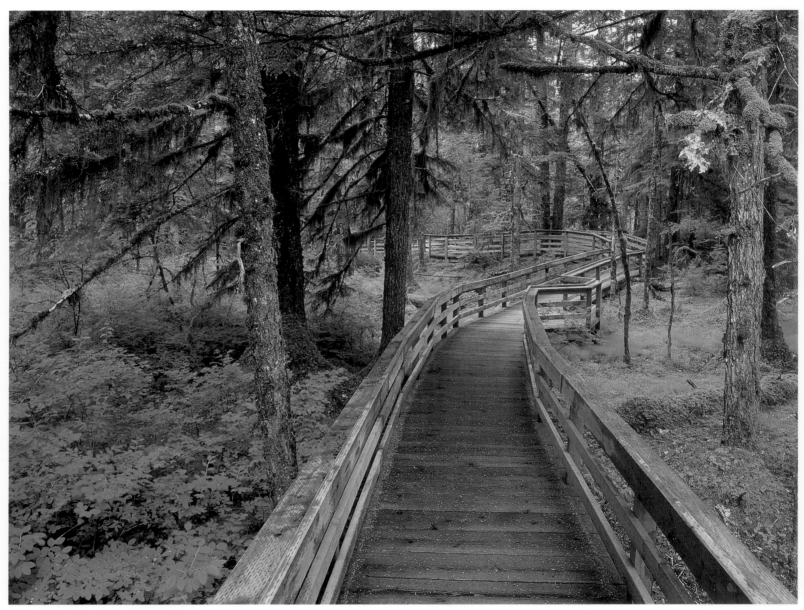

Boardwalk to Blackwater Pond, Bartlett Cove, Glacier Bay National Park

A FOREST OF HOPE

Southeast Alaska is dominated by temperate rainforest, one of the rarest biomes in the world, much rarer than tropical rainforests. Temperate rainforests exist only in coastal Alaska, British Columbia, Washington, Oregon, central Chile, and the South Island of New Zealand. Most of this forest in Alaska is within the Tongass National Forest, created in 1907 by President Teddy Roosevelt. At 17 million acres, it is the largest of 156 national forests in the United States. In the 1950s, two pulp mills (in Ketchikan and Sitka) were awarded lucrative contracts to harvest trees. By the 1970s and 80s this harvest was under serious attack, as entire valleys and islands had been logged, and the trees shipped to Asia to make "disposable" diapers and cellophane, among other things. To add insult to injury, the harvest occurred at a loss to American taxpayers because the U.S. Forest Service spent more money to process paperwork and build roads (into virgin forests) than it collected from timber companies that bid on the sales.

The Alaska National Interest Lands Conservation Act of 1980 created Misty Fiords and Admiralty Island National Monuments within the Tongass National Forest, and 14 wilderness areas off-limits to logging. The Tongass Timber Reform Act of 1990 added five more wilderness areas (to total 5.8 million acres of designated wilderness in the Tongass), and changed some policies. But the Tongass National Forest remains controversial amid changing demographics and values. Only four percent of the forest is composed of large cathedral-like trees (such as in the Kadashan Valley, on Chichagof Island, a threatened area admired by Juneau conservationist Lynn Schooler, right). Of that four percent, half has been cut: trees 800 years old felled in minutes by guys with chainsaws thinking about— what? Anything? "Any fool can destroy a tree," wrote John Muir. Who can build a living cathedral, a forest of hope?

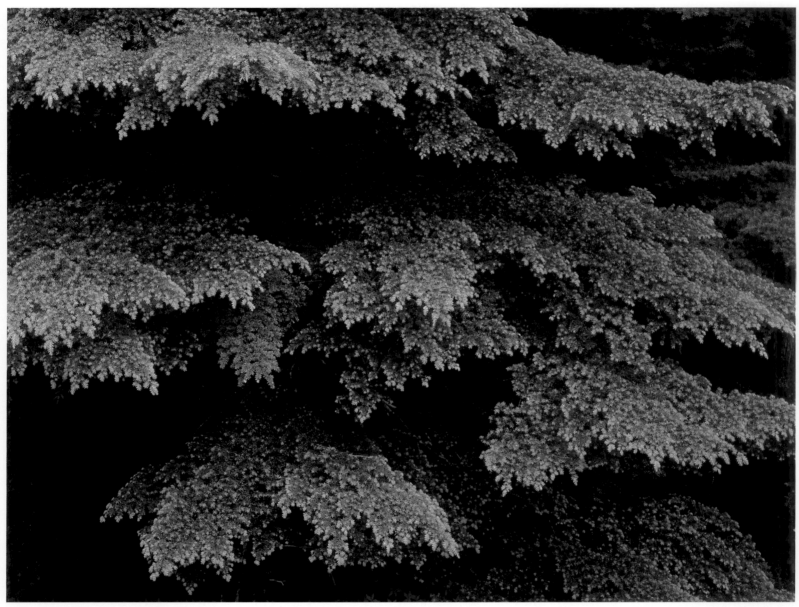

Western Hemlock, Prince of Wales Island

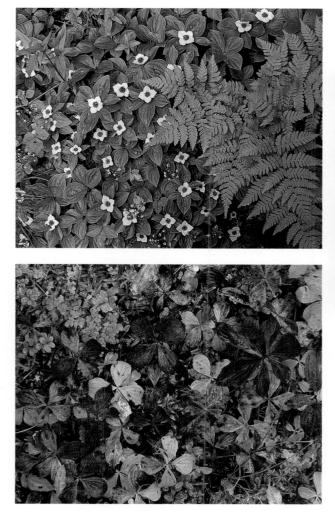

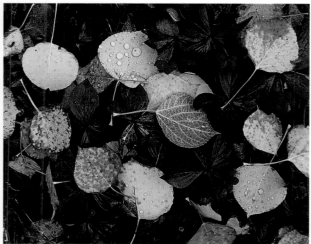

BUNCHES OF BUNCHBERRIES

Dwarf dogwood, also known as bunchberry (*Cornus canadensis*) shows three stages of its life cycle in this colorful trio. The four-petaled white flowers appear in June in woodland plants (upper left), and in July in alpine plants. Reproduction is by seeds, but also by underground stems (rhizomes) which form colonies of genetically identical plants. The advantage in rhizomes is that an area can be quickly colonized by the plant. The disadvantage is that because there is no genetic diversity, a single virus can kill the entire colony. The berries, more properly called drupes (above, photographed with fallen aspen leaves), appear in late summer and early autumn, and provide important food for voles and mice and forest birds. In Southeast Alaska, Sitka black-tailed deer feed on the leaves, which remain green throughout winter. Only those plants that grow on muskeg, in nutrient-poor soils, develop red leaves in autumn (left, photographed after a hailstorm on Chichagof Island).

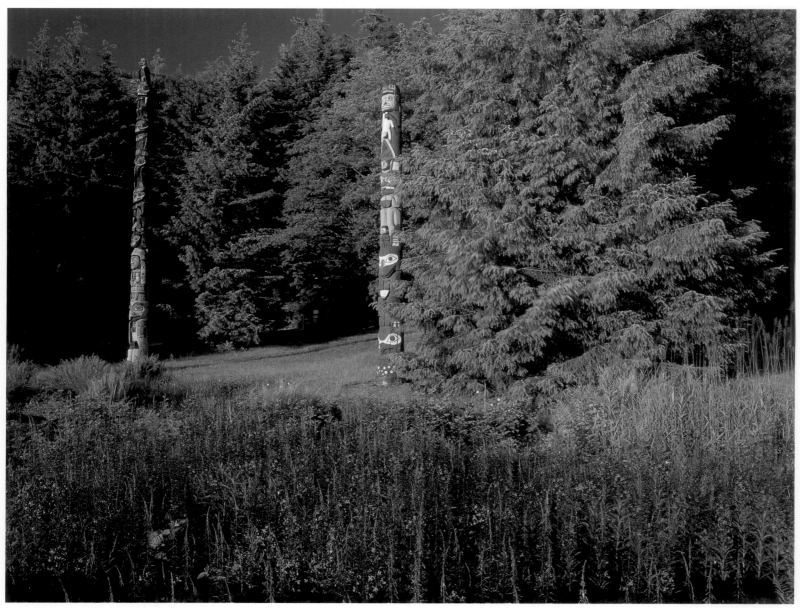

Totem Poles, Totem Bight State Historical Park, Ketchikan

THE RULES FOR PROGRESS

Totem Bight State Historical Park, in Ketchikan, is a handsome tribute to Alaska's Native heritage. From a parking lot at the entrance, a path slips through a forest, into a clearing and onto a boardwalk flanked by tall fireweed that bloom every July and August (opposite). Along the way, visitors discover one of the finest collections of totem poles in Alaska, and learn about the rich Tlingit and Haida cultures the poles represent. But walk down to the rocky shore below and a new Alaska comes into view: a glaring clearcut on the ridge above (right). Each year in Alaska there are more and more pretty pictures (in calendars, magazines, photo books, travel folders, and corporate brochures) but fewer and fewer pretty places.

While the tourism industry promotes one place, the timber industry destroys another, side by side. Art directors don't want pictures of this destruction. They say it doesn't sell. Wait a minute. Doesn't that subvert the truth? If we ignore a cancer will it stop spreading? In an attempt to make this book honest, a small percentage of the photography shows destruction, a percentage commensurate with the amount of Alaska that has been destroyed—modified, say industry spin doctors—by clearcuts, open pit mines, filled wetlands, gutted fisheries, dumped toxins, trammeled shores, boondoggle roads, oil spills large and small, the list goes on and on.

Alaska will always be wilder than Oregon, but will Alaska stay as wild as it was yesterday? At present rates of consumption, no. Boomers and developers (and the politicians they finance) say consumption isn't destruction it's progress—more jobs for more people for more security and opportunities and better investments and better schools and a better future. "Who writes the rules for progress?" asked Aldo Leopold in *A Sand County Almanac*. At what point do we lose more than we gain? If any place is ripe for redefinition, is it not Alaska?

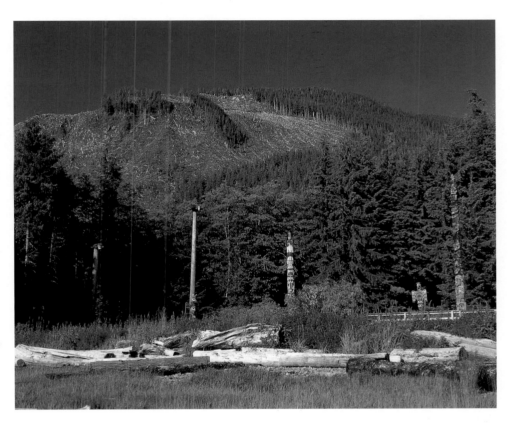

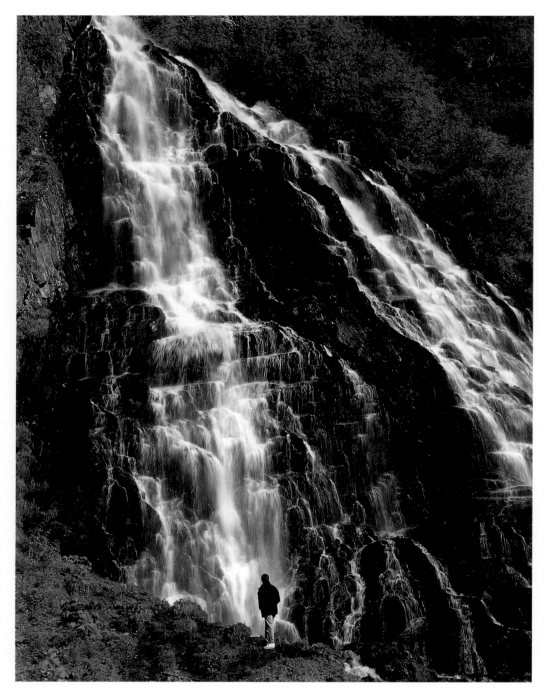

HUNDREDS OF YOSEMITES

When he traveled to Alaska in 1899 as a member of the prestigious Harriman Alaska Expedition, Henry Gannett, then Chief Geographer of the U. S. Geological Survey, wrote: "For the one Yosemite of California, Alaska has hundreds." The grandeur, he said, "is more valuable than the gold or the fish or the timber, for it will never be exhausted." Alaska has had its gold booms, fish booms, timber booms, and oil booms. Now it's tourism. As this fastest-growing industry expands, mining and logging practices once taken for granted are questioned.

Demographics change, values change, and people begin to agree with Gannett that Alaska's greatest asset is just being Alaska—untrammeled and wild. Yet tourism is also an industry dedicated to growth—and growth for growth's sake, wrote Edward Abbey, "is the ideology of the cancer cell." Tourism has already overwhelmed parts of Alaska with cruise ships, tour boats, buses, and helicopters. Quiet coves and bays are disappearing in the thump and throb of diesel and demand, a demand the tourism industry itself creates with embellished imagery and false promises. At places like Horsetail Falls, off the Richardson Highway in Keystone Canyon, near Valdez (left), busloads of passengers disembark and trample the trails. In the hamlet of Pelican, in Southeast Alaska, a tour boat disgorged so many passengers at once, the town dock sank. Alaska will always be grand and scenic, but only with careful management and strict limits will it remain quiet enough for a visitor to stand in a prism of northern air and hear a seal breathe across a cove.

THE THERAPY OF DISTANCE

From the autumn tundra slopes of Boreal Mountain, in Gates of the Arctic National Park (right), the North Fork of the Koyukuk River runs south toward Bettles and beyond. Bearberry leaves turn brilliant red in mid-August. Soon the snow will fall, the river will freeze, the sun will wink away, and the land will lock down for the winter. The Arctic Circle is eighty miles to the south, the Dalton Highway (formerly called the Hickel Highway and the Haul Road, constructed in the 1970s during the rush for Prudhoe Bay oil) is thirty miles to the east. There is a therapy in this distance. People in small numbers can spread out here and listen to the quiet. Bob Marshall did. He traveled here in 1929–31 and wrote, "I was happy in the immediate process of nature in its most staggering grandeur in living intimately with something so splendidly immense…"

Immense indeed. Gates of the Arctic National Park & Preseve is roughly four times larger than Yellowstone National Park, as it should be, since arctic ecosystems contain life in thin but far-ranging distributions. Bob Marshall wanted places preserved where, "No sight or sound or smell or feeling even remotely hinted of men and their machines." He wanted all of arctic Alaska saved as designated wilderness. He didn't get it. But he did manage to co-found The Wilderness Society, redirect recreation policy in the U. S. Forest Service, write a best-selling book, *Arctic Village*, and inspire the creation of Gates of the Arctic National Park & Preserve. Not bad for a man who lived only thirty-eight years.

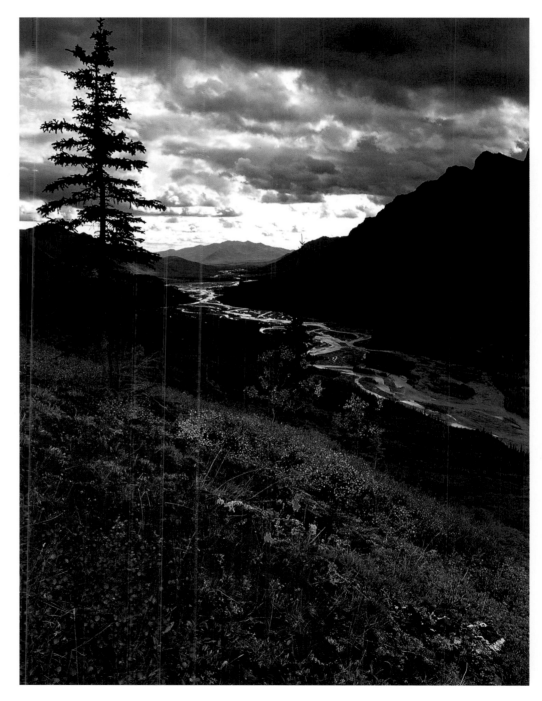

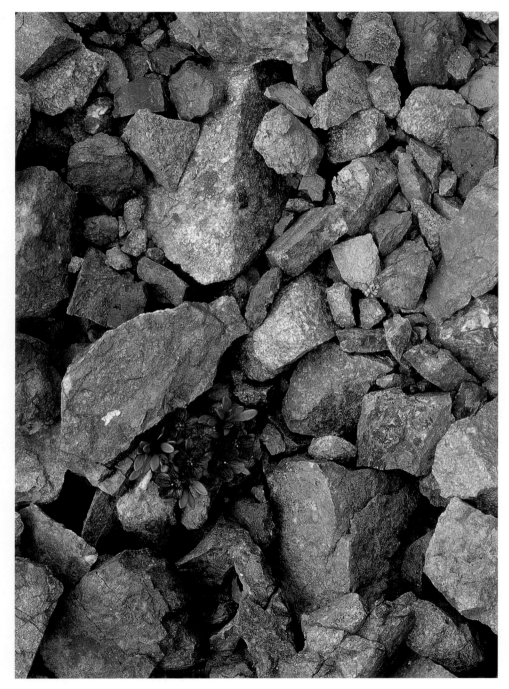

LIFE ON THE ROCKS

Scamman's spring beauty (left), a member of the purslane family, brightens a scree slope in the Alaska Range where grizzly bears, marmots, and red foxes live. The elevation is 5,000 feet. If it seems low, consider that an increase in latitude corresponds to an increase in altitude; 5,000 feet in Denali National Park is the ecological equivalent of 12,000 feet in the Colorado Rockies. Treeline is more than two thousand feet below this tough little flower. Go even farther north, beyond the crest of the Brooks Range (the Continental Divide in Alaska), and trees don't even grow at sea level. Yet flowers do. From the arctic coast to high rocky ramparts, flowers more than survive, they thrive. They hug the earth with bright blossoms—to attract pollinating insects—and quickly go to seed to shut down for winter, buried beneath a blanket of insulating snow.

While feeding on the nectar of a tall fireweed (opposite, upper right), a bee brushes against the stamens and transfers pollen from one blossom to another: not a bad arrangement for bee and flower. One feeds, one reproduces. Fireweed is a pioneering perennial that often thrives in disturbed areas: along roadways or burned areas. Hence its name, fireweed. Cold autumn mornings create a frosty patina on wild strawberry leaves (lower right). A member of the rose family, one-flowered cinquefoil (lower left) survives amid the ancient rocks and brutal climate of the Arctic National Wildlife Refuge. Also a perennial, cinquefoil blossoms in late June and quickly goes to seed in preparation for the coming winter when temperatures will drop to −50°F. Highbush cranberry (upper left) provides important food for birds as winter approaches.

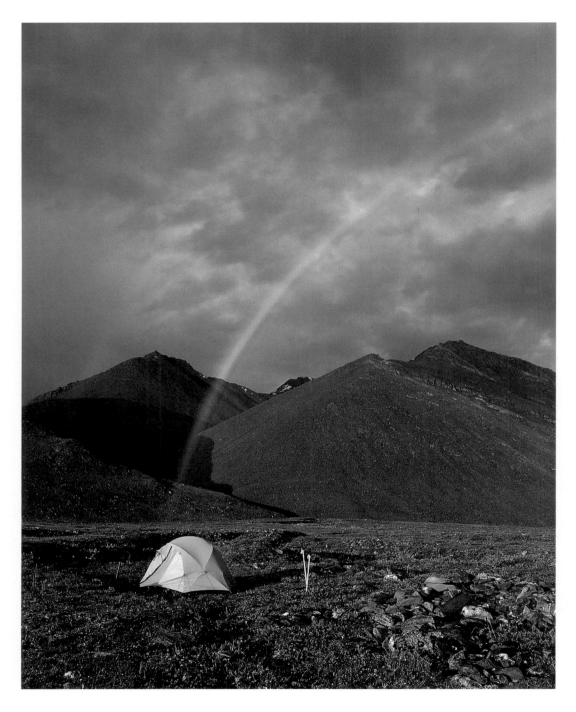

SLEEP WITH THE EARTH

"Now I understand the secret of making the best persons," wrote Walt Whitman in *Leaves of Grass*. "It is to grow in the open air, and to eat and sleep with the earth." If you cannot find your rainbow, perhaps it will find you, as it did with tent campers in the Romanzof Mountains of the Brooks Range (left), in the Arctic National Wildlife Refuge. It is June, 2:00 A.M., and a clearing storm serves to deepen the light. Sandpipers call from a nearby river, their voices melodic above the tumbling water. The sun hasn't set all night, and time itself seems like a prism. Night is not night, but only a refrain between dusk and dawn. Farther south, children partake of a September sunset below brooding skies on Wonder Lake (opposite), in Denali National Park.

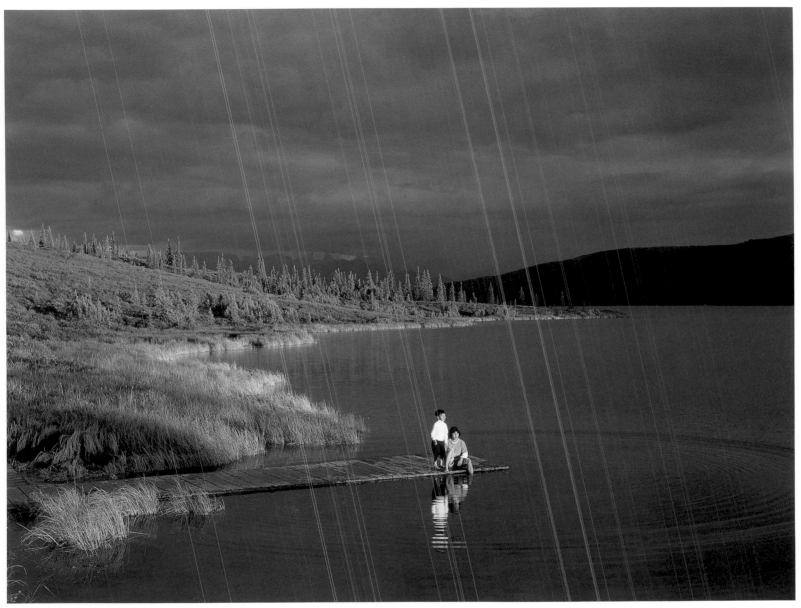

Wonder Lake, Denali National Park

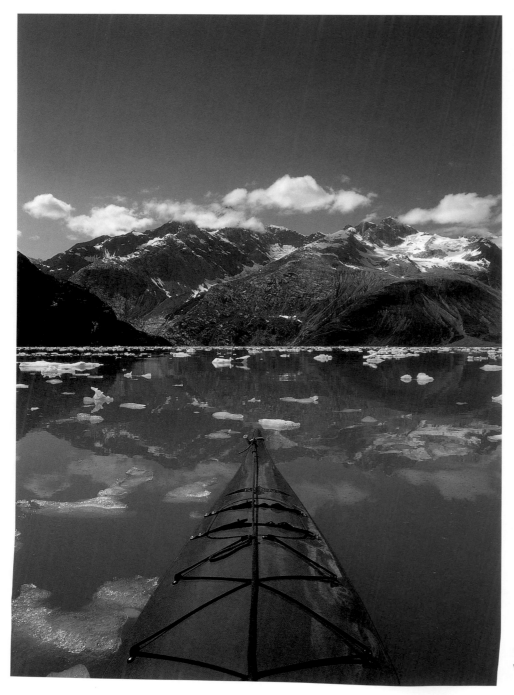

THE HIGHLIGHTS OF LOW RIDING

Far from the diesel-driven mantra of modern man, a kayak finds the shrinking silence of Alaska. There is no wind, no incessant buzzing of small airplanes filled with flightseers; there are no motor boats or other kayakers, yet. A rare moment. The tide rises and falls fifteen feet in twelve hours and creates strong currents in narrow channels. Best to have a tidebook and a watch, a compass and a map, a sense of humor and chocolate. Best also not to sneak up on seals, sea lions, and birds, as kayaks have stealth and their sudden appearance can frighten and scatter nearby wildlife. Around the point is a tidewater glacier that calves ice into the bay. Small bergs create a slalom course (left). Seabirds call. The sun shines. Then the wind kicks up and it rains for a week. Wet or dry, this time in the wild is an antidote to rap culture and the malling of America. That's why more and more people want to sea kayak in Misty Fiords, Tracy Arm, Admiralty Island, Glacier Bay, Icy Bay, Prince William Sound (opposite), Kenai Fjords, Kachemak Bay, Kodiak Island, the Katmai Coast, and elsewhere.

In some of these places, crowding makes backcountry quotas a necessity. "…The acceptance of such quotas is based on respect for the quality of the experience," wrote Roderick Nash in *Wilderness and the American Mind*. "One hundred people might be physically able to squeeze onto a tennis court, but the game they then played would not be tennis. So they wait their turn, placing the integrity of the game ahead of personal considerations. They realize, of course, that when they do get a chance to play, they will be accorded the same respect."

And their allotment of wind and rain.

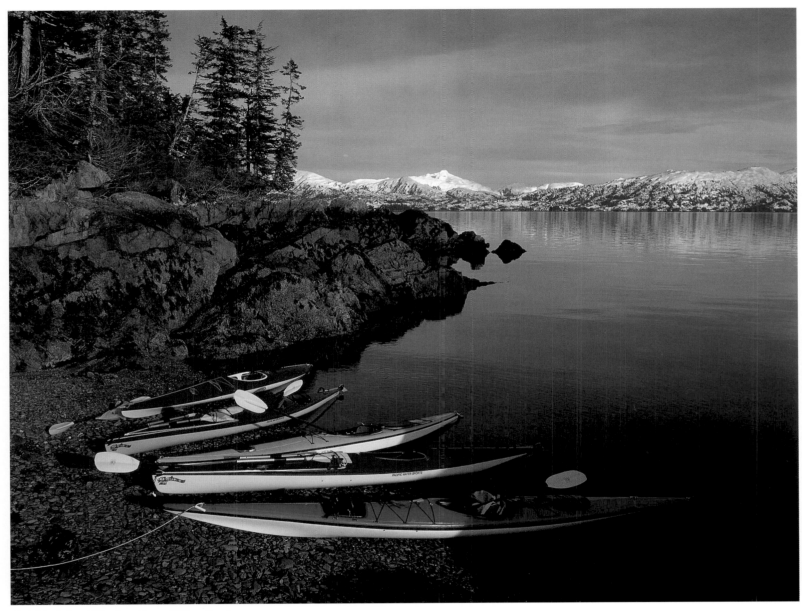

Mink Island, Port Nellie Juan, Prince William Sound

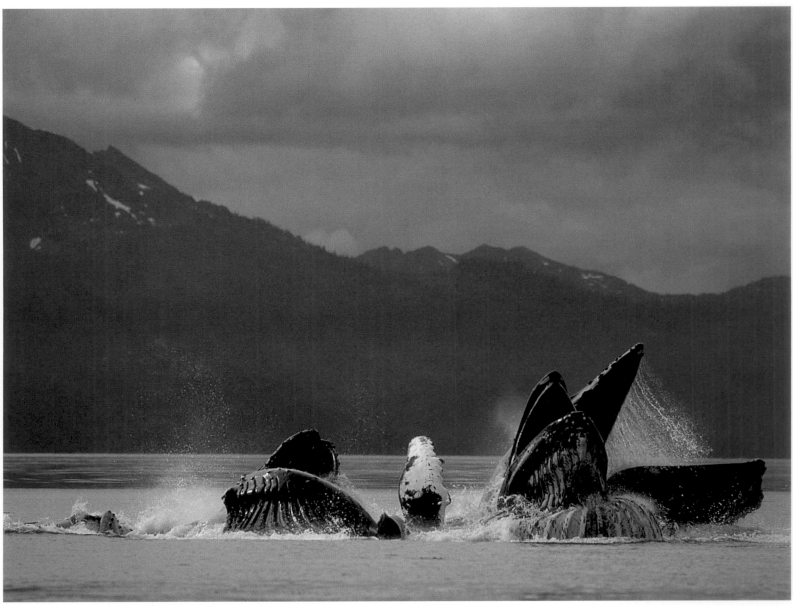

Humpback whales lunge-feeding, Southeast Alaska

WHALE TALES

Fifteen species of toothed and baleen whales swim the waters of Alaska, and every year tails and tales emerge. Beluga whales might be seen hundreds of miles up the Yukon River, or on a mud flat in Turnagain Arm where the second strongest tides in North America strand them. It happened to more than 100 belugas in August of 1996, and four died. Dark blue to gray at birth, belugas turn white by age six. Like belugas and sperm whales, orcas (a.k.a. killer whales) are toothed whales. They hunt in resident pods and transient pods, each with a fish and seal diet unlike the other. Bowhead whales are still hunted by Eskimos who use sealskin boats and hand-thrown harpoons, but who also carry cellular phones and emergency location transmitters. Gray whales migrate between Baja California and the Chukchi and Bering seas, an annual round-trip of 10,000 miles. An adult gray whale eats about 200 tons of small crustaceans in a single five-month Alaska season.

Most often seen are humpback whales that winter in Hawaii (where they fast and give birth to their calves) and summer in Southeast Alaska, where they feast on small fish and krill, eating up to a ton a day. A typical forty-year-old humpback will be forty feet long and weigh forty tons. Humpbacks are baleen whales—they have no teeth but rather long comb-like baleen (made of keratin, same as human fingernails) that hangs like curtains from their mouth and sifts their food. A clever feeding method involves the humpbacks diving below a school of fish. They spiral upwards while expelling air. The bubbles create a net that entraps, concentrates, and confuses the fish. The "bubble net" complete, the whales lunge through it to the surface with mouths wide open (opposite), and swallow large volumes of water and fish. They expel the water through their baleen combs, and swallow the fish. Humpbacks have a full repertoire of surface behavior, including full body breaches, flipper flapping, and tail lobbing (right). None of the whale behavior is fully understood by humans, as probably our behavior is not by them.

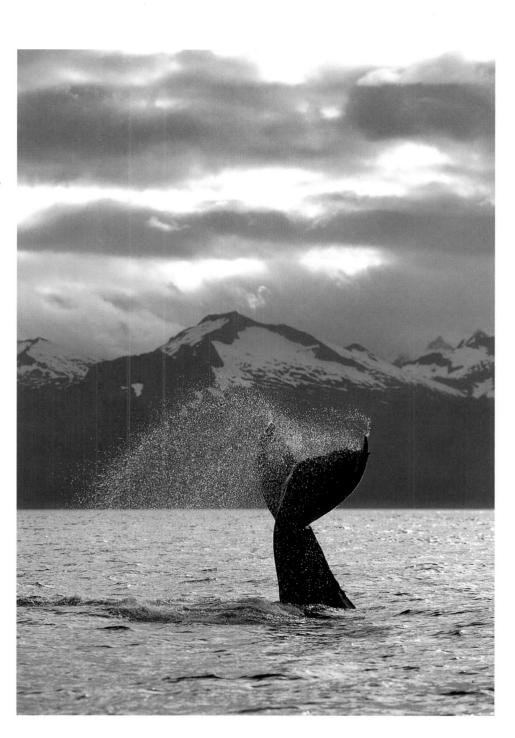

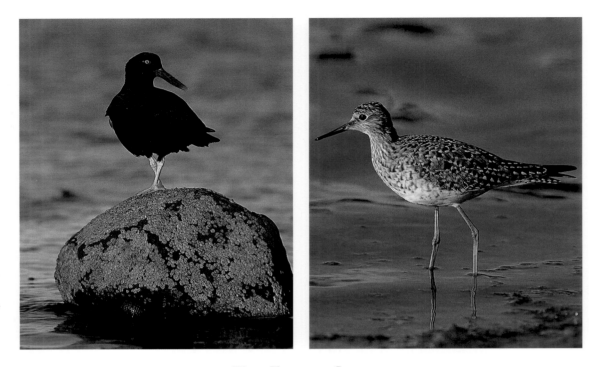

THE FERTILE SHORE

When ecologists talk about ecotones and the "edge effect," they mean the margins between habitats that create biological richness. Shorelines are a good example, where tides rise and fall as much as twenty feet in some parts of Southeast Alaska. The intertidal zone abounds with algae, limpets, clams, mussels, crabs, urchins, starfish, barnacles—a veritable seafood buffet for birds with beaks and bills designed to eat there. Roughly 40 species of shorebirds inhabit Alaska in summer, among them the black oystercatcher (above left) and the lesser yellowlegs (above right). Both species winter as far south as South America, although some of each stay year-round in the contiguous United States, and in fact a few oystercatchers remain in Alaska during mild winters. The oystercatcher uses its bright red laterally-flattened bill to pry open mollusks (mussels and clams) and to probe soft substrates for marine worms. The yellowlegs probes for small crustaceans (amphipods and copepods). The west coast of Chichagof Island (opposite) offers shores as wild and fertile as they were centuries ago, long before ecotone and edge effect entered our vocabulary or land ethic.

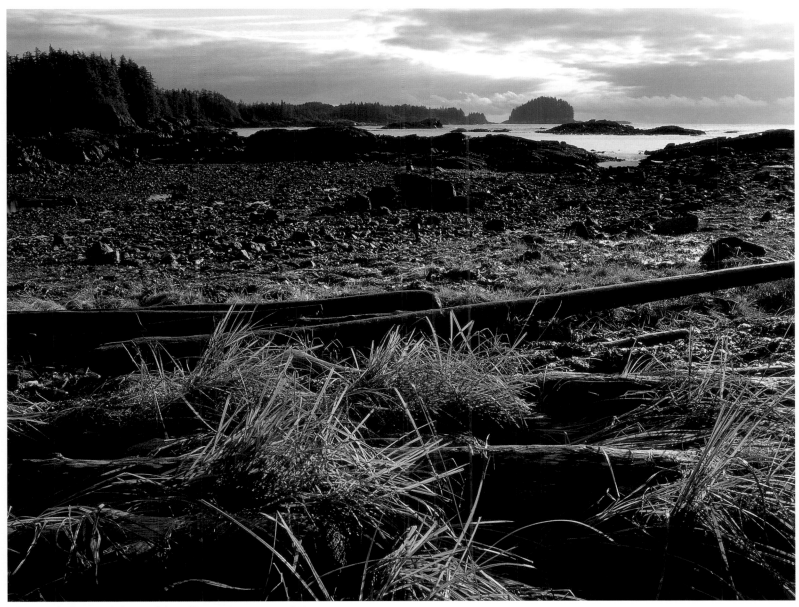

Chichagof Island, West Chichagof-Yakobi Wilderness, Tongass National Forest

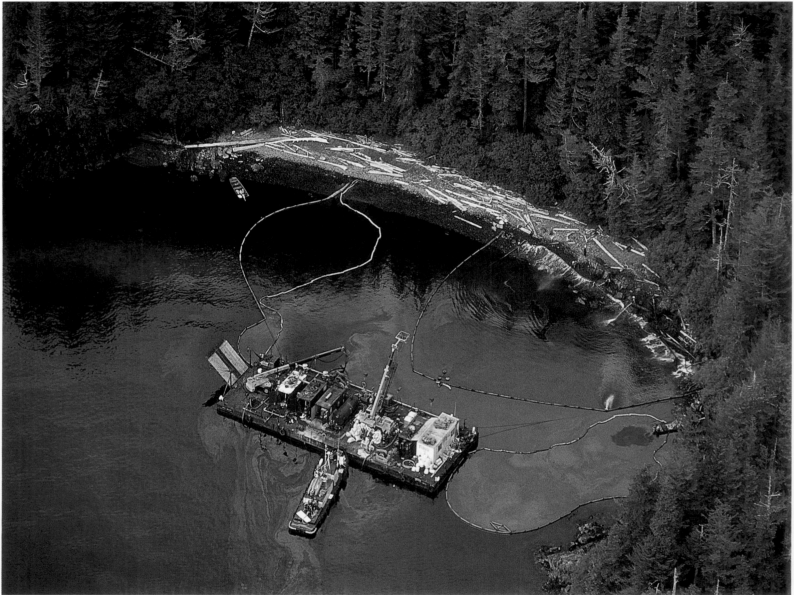

Clean-up barge at work, Prince William Sound

46

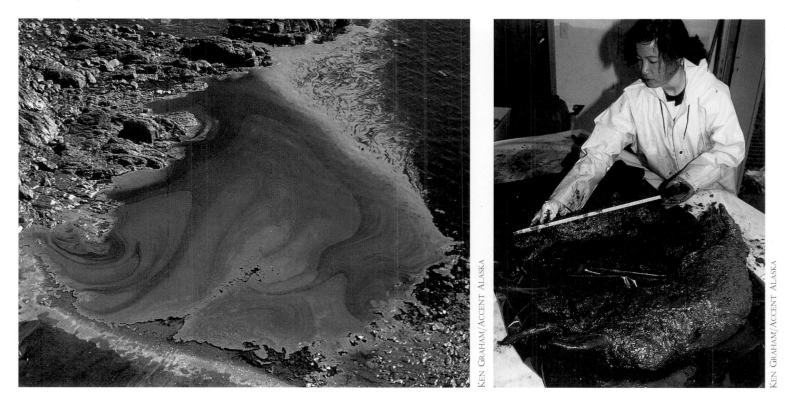

THE DAY THE MUSIC DIED

When the 987-foot long, single-hull supertanker *Exxon Valdez* hit Bligh Reef in March of 1989 and hemorrhaged 11.3 million gallons of North Slope crude oil into Prince William Sound, the cost was measured in chaos and death. Countless dispirited people believed Alaska would never again be the same. The inevitable and the impossible had happened: inevitable to those who never trusted the oil industry in the first place, impossible to those—most Alaskans—whose lives had been made comfortable by the same industry, who believed modern maritime and environmental safeguards would never let such a thing happen. Biologists became morticians as they examined the oiled carcasses of sea otter pups (above, right), bald eagles, and a sorry cast of thousands of other birds and mammals caught in the spill. Entire bays and islands were slimed in a toxic tide (above, left) that spread from Prince William Sound to Kenai Fjords to the Barren Islands, Shuyak Island, and beyond to the Katmai coast, and southwest down the Alaska Peninsula—more than 1,500 miles of shoreline.

In his book *In the Wake of the Exxon Valdez*, Art Davidson summarized: "The inescapable conclusion is that the basic premise supporting North Slope oil development was false. No safety net existed to guarantee effective spill response. Stated simply, environmentally-safe oil development and transport were and are impossible: they always entail some degree of risk." Researchers continue to monitor the long-term effects of the spill on fish and wildlife in Prince William Sound.

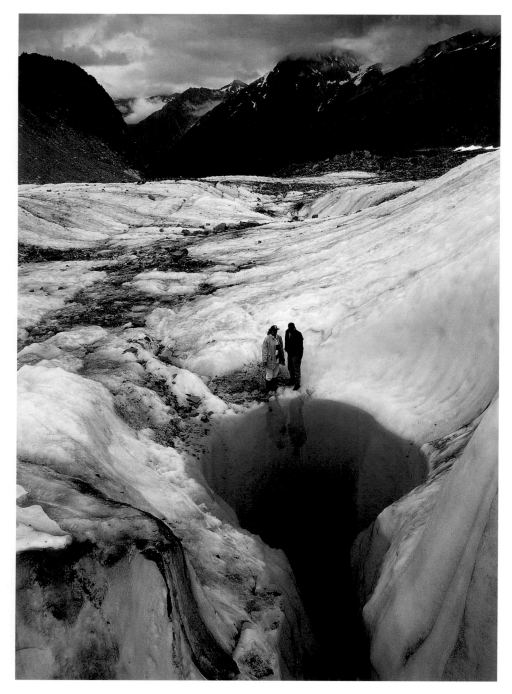

WHITE SKIRTS AND BLUE ICE

In the late 1800s when most men came to Alaska looking for gold, John Muir came looking for glaciers. What he found thrilled him. "The clouds began to rise from the lower altitudes," he wrote, "lifting their white skirts, and lingering in majestic wing-shaped masses about the mountains that rise out of the sea. These were the highest and whitest of all the mountains, and the greatest of all the glaciers." Muir had found his heaven on earth. He described glaciers as having "...many shades of blue, from pale, shimmering, limpid tones...to the most startling, chilling, almost shrieking vitriol blue."

He walked onto a glacier when he was ill, believing that no lowland grippe microbe could survive on the ice. He crossed a glacier with a little dog named Stickeen, got trapped in a maze of crevasses and had to cut a walkway over a fin-backed icy precipice to get across. Afraid to follow, Stickeen began to whimper. From the other side of the crevasse, Muir said, "Hush your fears, my boy, we will get across safe, though it is not going to be easy. No right way is easy in this rough world. We must risk our lives in order to save them." Stickeen rallied and made it across, and became Muir's close friend.

Travel onto Alaska's glaciers today is still adventurous, though in most cases not silent or arduous. People land in helicopters and walk about to admire features such as deep meltwater pools (left). The ice remains as blue as in Muir's day, in both glaciers and icebergs (opposite). The blue is more intense on cloudy days, and in dense, crystalline ice. When light hits the ice, all colors of the spectrum are absorbed except blue, which is refracted and scattered and thus visible to humans.

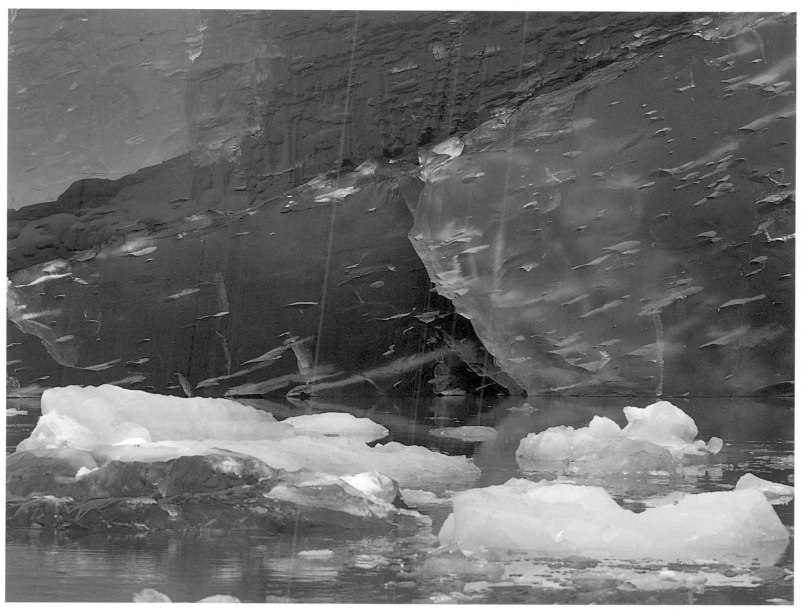

Glacial ice in Tracy Arm, Tongass National Forest

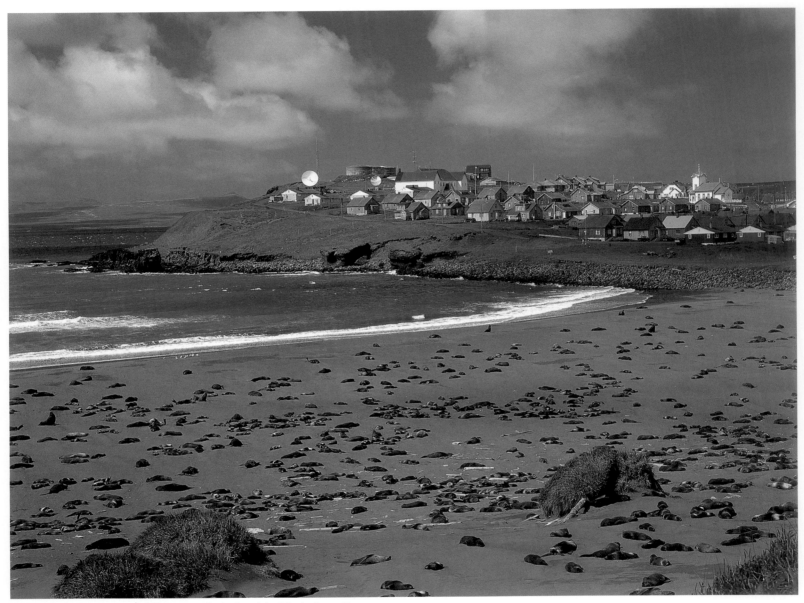

Northern fur seals and St. Paul Village, St. Paul Island, Pribilof Islands, Bering Sea

Only in Alaska

A motorhome from Georgia pulls into a gas station in Valdez. Inside is a retired couple with no kids. The husband gets out to help the attendant pump gas. The wife, who moves more slowly, decides to walk her little lap dog. Because this is Alaska, the last frontier, home of husky and malamute and sundry Jack London legends, the wife feels that a leash is unnecessary. Her little dog can be wild up here: run with wolves, howl at the moon, bark at bicyclists.

Suddenly from nowhere a bald eagle swoops down, grabs the dog and flies away on broad, beating wings. The wife screams as she watches her wonder dog disappear into the wild skies of Alaska hanging from lethal talons like a salmon with fur. She bursts into tears. Her husband runs to her, comforts her. He helps her back into the motorhome, speaks tender words to her. She nods and sobs. She cannot believe this has happened. The husband walks to the back of the motorhome, to where his wife cannot see him, and dances a jig. He kisses the sky and praises divine intervention. He puts on his best sad face, walks to the front of the motorhome, climbs in with his distraught wife, comforts her more, and drives away.

A headline in the *Anchorage Daily News* the following morning reads: "Georgia Dog Joins Alaska Food Chain."

A ferocious early winter storm rakes across the Arctic Coast as a lone Inupiat Eskimo drives for home in a snowmachine (what people outside Alaska call a snowmobile). He pulls a sled full of gear, and a seal he shot on the sea ice. The sun winks away to the south as darkness descends and the temperature sinks to −20° Fahrenheit. Fifty miles from home, in the frigid

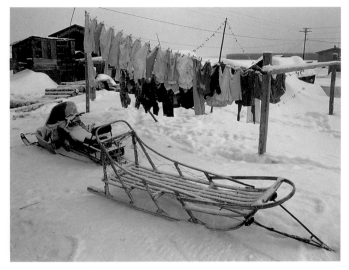

Laundry day in Kaltag, Yukon River

middle of nowhere, the snowmachine breaks down. The Eskimo discovers that a torque arm has broken and jammed into the track. The engine still runs, but the snowmachine won't move. He has tools and supplies to replace spark plugs and fan belts, but nothing like this. By headlamp and hunting knife, he cuts open the seal and removes a rib. He takes off his mittens and whittles the rib into the size and shape of the torque arm. He must do this twice, as the torque arm on the other side has also been damaged. Then with nylon line he ties the bones in place. His mittens back on, he climbs onto the snowmachine and makes another few miles before the bone snaps and the track jams. Once again, he repeats the procedure and makes another few miles before that bone snaps. Again and again, with mittens off and fingers stiffening in the cold, he repeats the procedure all through the night, each time gaining a few more miles, working and traveling by headlamp and hope, until he finally reaches home, half frozen but alive. His worried wife asks him what happened. She was just about to send out a search crew. Just a little problem, he says. Not to worry. He's fine.

Fishermen in a skiff watch two moose swim across Icy Strait, near Glacier Bay, when suddenly a pod of orcas—also known as killer whales, wolves of the sea—attack the moose. The fishermen watch, amazed, as the orcas kill and eat one moose, and blood stains the sea. The second moose escapes into a bed of kelp. The orcas circle it, but are unable or unwilling to penetrate the thick kelp and grab it. They leave, but the second moose doesn't last long. Having become entangled in the kelp, it fights to free itself, fails, and drowns.

A few years later, in almost the same place, passengers on a cruise ship observe a pod of orcas attack a minke whale. By the time biologists from

Glacier Bay National Park arrive, all that's left of the twenty-ton whale are pieces of carcass.

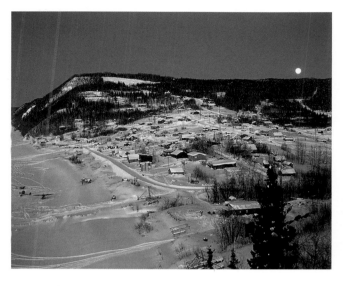

Near Cordova, two elderly women visit the Childs Glacier where it flows into the Copper River. On the riverbank, opposite the glacier, a U.S. Forest Service sign instructs the women to climb a wooden viewing platform, where they will be safe should the glacier calve ice into the river and create a wave that might wash onto the bank and get their feet wet. The face of the glacier is fractured into tall minarets of ice, called seracs, and the women agree: to see one of these fall into the river would be exciting indeed. But before they have time to ascend the platform, a huge section of the glacier—not one minaret but many—falls into the river in one gigantic thunderous calving. A tsunami rolls toward them. Uh-oh. They wonder, Does this happen every day? Are we okay?

The next thing they know, they are lying on their backs, soaking wet. The wave from the icefall has picked them up and thrown them into an alder thicket. One woman has a broken pelvis, the other is not seriously hurt. They are not the only fish out of water. Flopping on the ground all around them are salmon. "At first I thought they were snakes," said one of the women.

She had nothing to fear. There are no snakes in Alaska.

The winter weather is unusually cold when a man departs Petersburg in his boat to go deer hunting on Admiralty Island. In a quiet bay he sees two Sitka black-tailed deer, a doe and a fawn. They are not on shore, but rather stranded on a drifting ice floe, paralyzed with fear. He approaches slowly,

A simple life in Southeast Alaska

engines low; comes alongside, lifts the two deer into his boat, first the fawn, then the doe. They curl together on deck, motionless, silent. The fawn shivers against its mother. This intrigues the man because he's hunted deer for many years, and seen them bedded down when it's terribly cold, and not even move when he walks up to them.

But he's never seen a deer shiver. He covers the fawn with a blanket and motors to shore, where he gently lifts doe and fawn onto solid land. They stand on wobbly legs for a moment, then bound toward the forest, suddenly graceful with ancient faculties and fears. At the edge of hemlock and spruce they pause to look back in a transcendental moment, then slip away.

The man returns to Petersburg, puts his rifle on the rack and leaves it there for a long time.

Another man from Sitka hunts deer on Chichagof Island. He has just lost his father to cancer. He pauses on the edge of the muskeg, and waits. He finds a raven feather; picks it up, puts it back in precisely the same place and position he found it. He thinks of the man who taught him to hunt, to grow a garden and build a cabin; the man who told him to never speak proudly of killing an animal, for such talk would bring dishonor to himself. He shoots a deer and packs out the meat and cries that night in his camp, filled with loss and joy. Some things will never be the same, he knows, and others things are they way they have been since the beginning of time.

Shortly after an Alaska Airlines jet takes off from Juneau International Airport, the pilot radios the tower and requests an emergency landing. A salmon has landed on the windshield and slimed his view. Seems the jet

startled a bald eagle into dropping its lunch. The jet lands safely, with passengers and crew unhurt. The salmon doesn't fare so well. The unidentified eagle files no report with the FAA.

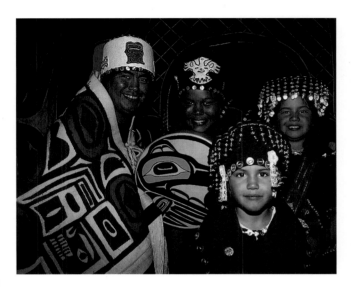

Tlingit dancers, Saxman

During the EXXON VALDEZ oil spill that created a toxic black tide on more than 1,500 miles of Alaska coastline, a man from EXXON flies into Anchorage, rents a car and departs for Valdez, terminus of the Trans-Alaska Oil Pipeline. He intends to take the Glenn Highway northwest to Glennallen, then turn south on the Richardson Highway to Valdez. An easy 300 mile drive. He's from Texas and not intimidated by big country. But he makes a wrong turn and ends up going due north on the George Parks Highway. He has no map, but is certain this must be the right road. He's never been lost before, never been to Alaska either. He drives through Wasilla, Willow, even a place called Houston—nothing like the Houston he knows. About 100 miles north of Anchorage he stops at a lodge/cafe and mentions that he's with EXXON and on his way to Valdez. He's got important business there. Workin' on the spill. Gonna clean up Alaska. By the way, he says, this doesn't seem like the right road. Is this the way to Glennallen?

Hey buddy, an Alaskan implies, you're doin' great. Just keep goin'.

The Texan thanks him and continues on his way. Four hours later he's in Fairbanks. He's driven 360 miles from Anchorage, and is 50 miles farther from Valdez than when he began.

Three mountaineers climb a glacier at 10,000 feet in poor weather in the St. Elias Mountains. They move slowly, tied together with a 150-foot length

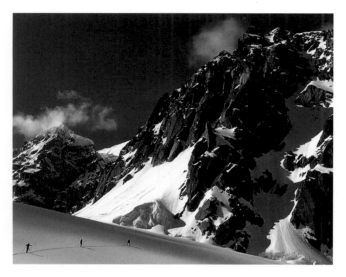

Skiing the Ruth Glacier, Denali National Park

of rope. Each carries a backpack and pulls a sled full of gear. Each holds an ice axe in one hand, and is prepared to self arrest—fall to his belly and jam the axe into ice and snow—should a ropemate suddenly fall into a crevasse. In theory, the arrest will stop the ropemate's plunge into the icy tomb. The crevasses are not visible; they lie undetected under last winter's new snow. In all directions—underfoot, overhead, on every horizon—the climbers see nothing but ice, snow, and fog. Severe whiteout conditions. They stop, hold their position, and decide to wait for the weather to clear rather than walk in the wrong direction and step off a cliff. It happens every year. Lives lost, loved ones never seen again. Mountain climbing is not the most dangerous occupation in Alaska—that belongs to commercial crab fishing in winter in the tempestuous Bering Sea— but it's not as safe as selling shoes in Nebraska. It takes lives. One minute your best friend is beside you, laughing, the next minute he's dead.

Oddly, there is no wind. And it's not that cold. The climbers use long, thin metal wands to probe for crevasses. Finding none, they sit together and eat lunch. They agree: it sure is wild up here. We must be the only living things for miles. Just then something moves in their peripheral view. What was that? They squint. It disappears in the shifting fog. Must have been a mirage. It appears again, moving at an oblique angle to them, maybe fifty yards away.

A wolverine.

The three mountaineers stare in disbelief as the animal passes by and hardly gives them a second look, head down, shoulders forward, pace deter-mined, late again in a world only a wolverine understands. It disappears into the fog and myth, to be embellished forever by three mountaineers who thought they were alone at 10,000 feet in the St. Elias Mountains.

Newcomers to Juneau meet a nice man on the street during their morning walk. He too is out walking. They are pleased he is so friendly, since they know nobody else in town. They see him again and again. He always seems undisturbed by the rain, and always offers the same cheerful greeting. Then one day they see his photograph in the newspaper and discover he's no ordinary man. He's the governor of Alaska.

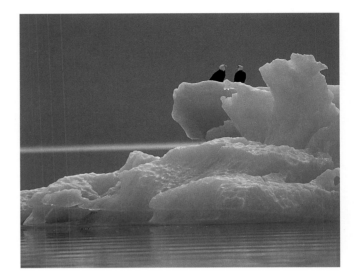

Bald eagles on an iceberg,
Kushtaka Bay

Early in July, two biologists travel by skiff along the Colville River—largest river in Arctic Alaska—to map peregrine falcon nest sites. The project requires no other data; no hours or dates, so the two men decide to pitch their watches and travel, work, wake, and sleep free from a rigid routine.

The weather is heavy overcast for—what? A week? Ten days? Hard to tell. No idea where the sun is. Every day a dull gray light shapes time into a measureless ghost. Because the sun is always up, but the sky always overcast, morning, afternoon, evening, and night melt into one. When one of the men digs through his gear he makes a disturbing discovery: he finds his watch. It says six o'clock. Must be six in the evening, he says. No, the other man says, must be six in the morning. They sit in silence, then agree: what does it matter? They stuff the watch deep into the pack, bury it, banish it, and decide to make a burrito dinner. Or is it a burrito breakfast?

Ten passengers on a cruise ship share the same dinner table every night. Only one of them has been to Alaska before, a man with snow-white hair who flew for the Navy in the Aleutian Islands during World War II, fighting the Japanese. This is his first time back. As the days pass, the passengers get to

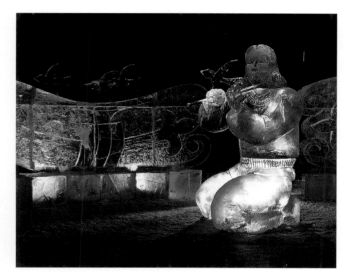

Ice sculpture "Melody," international competition, Fairbanks

know each other and become friends. En route to Sitka, they see humpback whales. That night at dinner, everybody is abuzz about the great leviathans. But the former Navy man says very little; he seems preoccupied. Finally he tells the others that when he flew bombing missions during the war, he was ordered to land with an empty load of munitions. Too dangerous otherwise. So he and his fellow airmen dropped their bombs at sea. "On whales when we could find them," he says. "We laughed about it back then, but I feel terrible about it now." His sad eyes plead for forgiveness. The other passengers console him. The war is over, they tell him kindly, with both the Japanese and the whales.

Several Alaskans sit in a roadhouse cafe in Tok and talk about Alaska: outdoor adventure, wildlife, big fish in the rivers, little minds in the state legislature. Their discussion spirals onto caribou. The thirteen herds that inhabit Alaska. For a long time they discuss the Porcupine Caribou Herd, 160,000 animals that winter in Canada's Porcupine River drainage (hence the herd's name) and every spring migrate to Alaska's Arctic National Wildlife Refuge. In June the pregnant females give birth to their calves in the Refuge, right where the oil industry wants to drill for another big strike—an elephant, they call it—big like Prudhoe Bay.

A young woman enters the cafe and sits behind the Alaskans. A Californian, she has never been to Alaska before. She's fascinated to hear stories from the neighboring booth; stories of the Arctic, the tundra, the Porcupine Herd, the mysteries of migration, the deeper mysteries of politics. She can only hear bits and pieces of what is said. She wonders: can little minds control big oil?

A waitress offers to take her order. She says she'll wait for her friends,

who are parking the car and will join her shortly. The Alaskans finish their coffee and sourdough pancakes, pay their bill and leave. The young woman is full of questions, but restrains herself. When her friends arrive, she bursts with excitement, "You won't believe what I just heard…"

Outside, one of the Alaskans realizes he forgot his coat. He goes inside, and hears the young woman telling her friends, "It's true, I heard them say it."

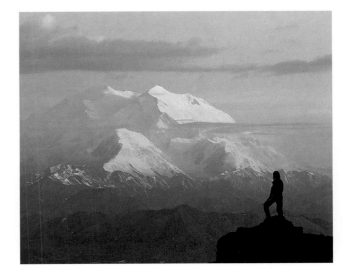

Sunset on Mt. McKinley, 11:00 P.M., Denali National Park

"One hundred and sixty thousand?" one friend asks incredulously. "I can't believe it."

"It's true," she says.

"Swimming rivers and eating lichen and giving birth on the tundra?" asks another friend. "I thought porcupines lived in the forest."

"Not in the Arctic I guess," the young woman says. "Look, I'm just telling you what I heard these people say. They called it the Porcupine Herd. They said the porcupines migrate together every year, and have their babies in the same place where the oil industry wants to drill for an elephant."

"An elephant?"

"That's what they said."

"Maybe they meant a mastodon or a woolly mammoth or something."

"I don't think so. They said an elephant."

Unnoticed by the young woman, the Alaskan quietly grabs his coat, grins, and slips away. ❧

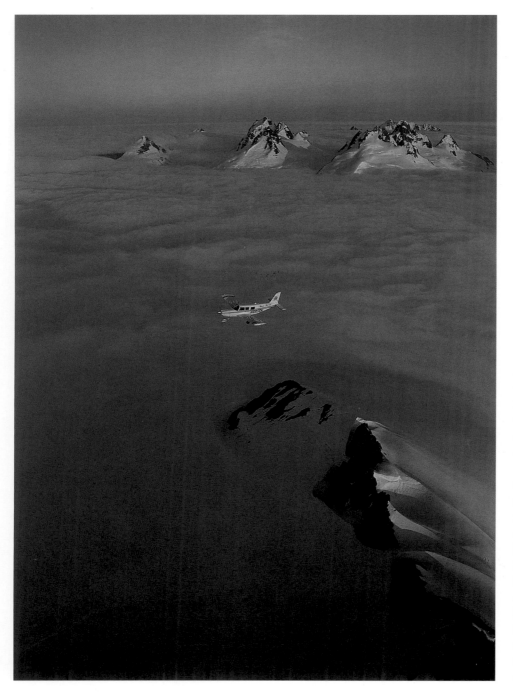

SLED DOGS, AIRPLANES, AND A GREAT WHITE SILENCE

Long before the Iditarod Trail Sled Dog Race from Anchorage to Nome (on frozen Norton Bay, opposite), sled dogs delivered mail and supplies in winter in Interior Alaska. Then came the 1920s and pioneering airplanes and the daring pilots who flew them: Carl Ben Eielson, Bob Reeve (the original glacier pilot), Joe Crosson, and perhaps the most daring of them all, Harold Gillam, who flew into storms and inspired one schoolboy to write: "He thrill em, chill em, spill em but he no kill em Gillam."

While planes today provide essential services between many remote villages and towns (70 percent of Alaska's settlements are not reachable by road), they also intrude in some places. Even in Denali and Glacier Bay (left) and other national parks, the sound of them cannot be escaped. Kayakers and campers who come to Alaska for the greatest healing experience of their lives are stuck listening to buzzing, whining, mechanical gnats all day long. Planes more irritating than mosquitoes. Planes that drown out loon song and wolf howl. Planes important in moderation but irritating in excess. By contrast, sled dogs might bark excitedly when in harness and ready to run, but once on the trail they settle into a steady quiet trot, and the musher enjoys a great white silence, precious as a good friend.

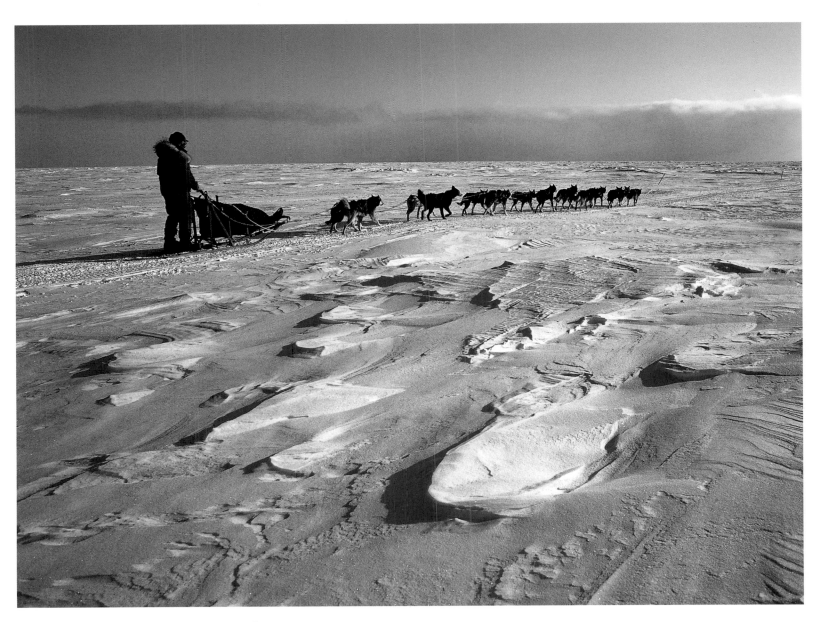

Iditarod musher and dog team, frozen Norton Bay, near Elim

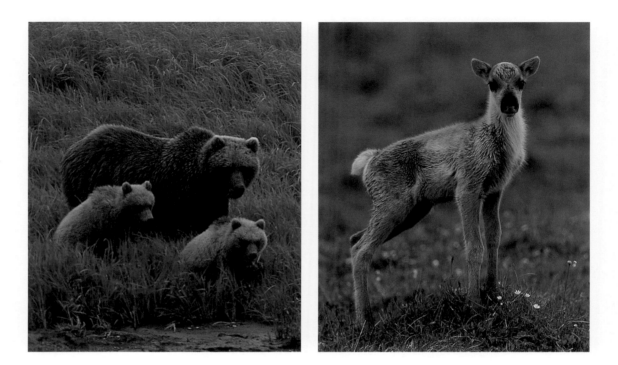

CUBS, CALVES, AND SURVIVING THE ODDS

We consider young animals cute, but nature has no such sentiments. Wild Alaska offers no handicap for being fuzzy or cuddly. Born in a den in winter, brown bear cubs must stay close to their mothers in summer (above left). They must develop quickly, be watchful, and learn to fear large males (boars) that will attack and kill them. Females (sows) defend their cubs fiercely but not always successfully. An aggressive sow might steal a cub; another sow might adopt a cub that has lost its mother. A caribou calf (above right, three weeks old) is born on the tundra in late May or early June. In ten days it can outrun a bear; in six weeks, a pair of wolves. If food is abundant and the weather kind, and if predator densities are low, up to eighty percent of all newborn caribou calves can survive the first year. But if conditions are poor (even with good birth rates) every calf in a herd can succumb to starvation, predation, or disease.

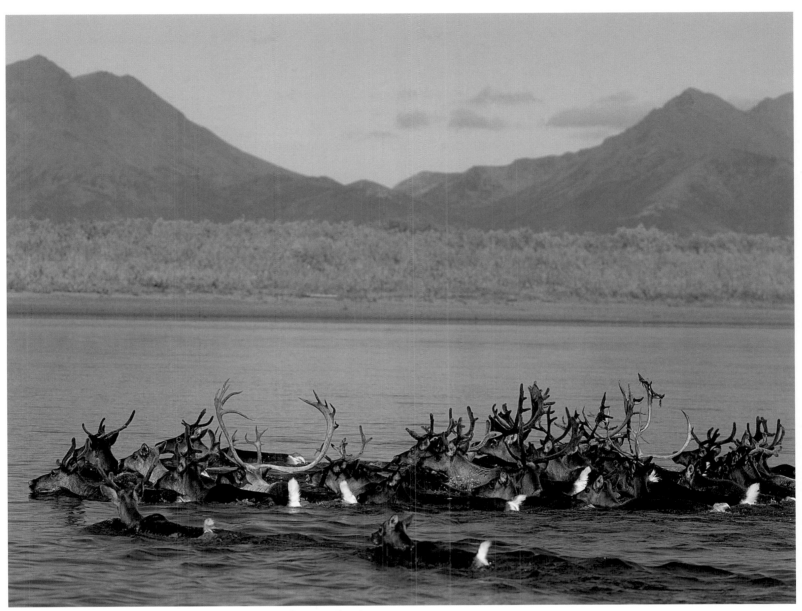

Caribou bulls, cows, and calves swim the Kobuk River in Kobuk Valley National Park

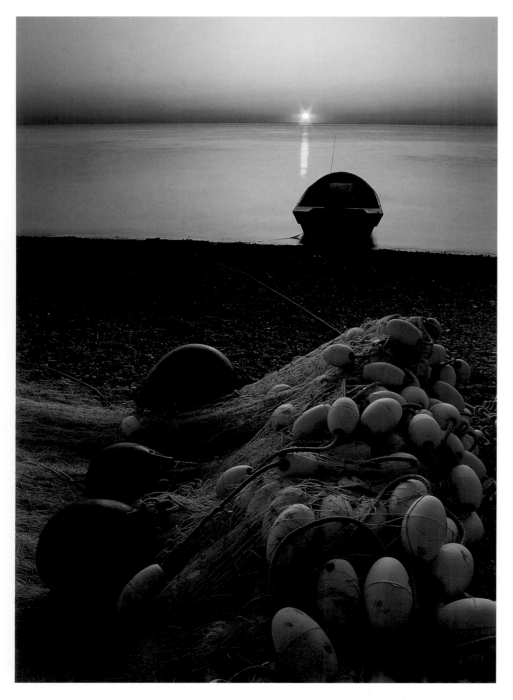

A FISHING LIFE

From one corner of Alaska to another, fishing is a way of life. (Opposite: Dungeness crab pots stacked dockside in the Southeast community of Pelican, on Chichagof Island. Left: a net and buoys at sunset on the beach in Kotzebue, on the northwest coast of Alaska, 26 miles north of the Arctic Circle.) Alaska's commercial fisheries account for more than fifty percent of total seafood production in the United States. Roughly six billion pounds of seafood is harvested annually here, worth more than a billion dollars. Prices and volumes vary annually. One year the Bristol Bay sockeye salmon run might be much stronger than predicted, another year much smaller. Some salmon runs have been augmented (and perhaps tainted) by hatchery-reared fish. Others remain wild.

While commercial fisheries collapse around the world, many of Alaska's fisheries remain strong. Still, there are problems. The bycatch in some regional fisheries (volume of nontargeted species that are killed and discarded) remains high, in some cases higher than the region's entire catch from sport fishing. Mercury poisoning has been found in the Bering Sea. Some salmon and king crab fisheries have collapsed from overharvesting and have been slow to recover. Steller sea lion populations have dropped ninety percent in some places, in direct correlation with an intensified pollock fishery. In past years drift nets, tens of miles long, have been curtains of death in open seas that killed uncounted societies of birds and marine mammals. For both fish and fishermen to survive in stable numbers, everybody must accept strict quotas, which most fishermen do. The year's salmon escapement (the number of fish that make it upstream to spawn) is as important as the year's catch, as it insures a future in fishing, and hopefully a future for seals and sea lions too.

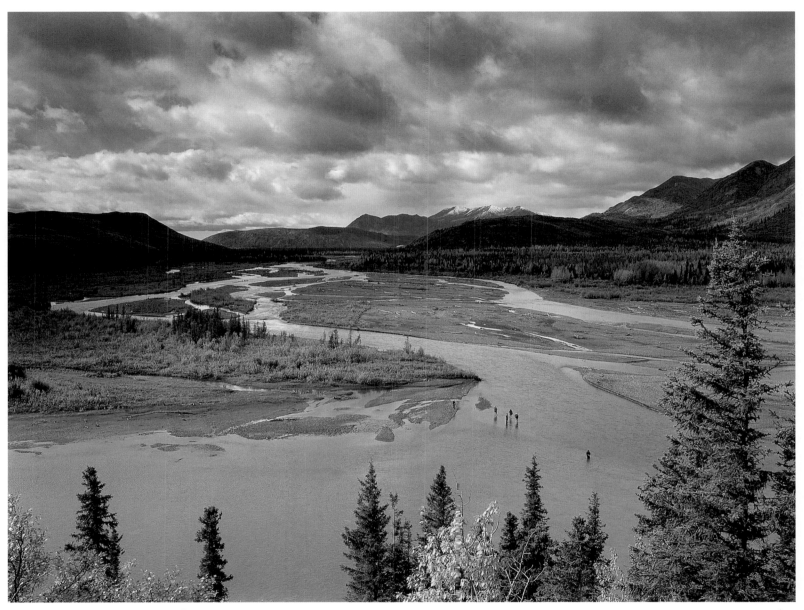

Fishing in the Nenana River, near Cartwell

SAVING SOULS

It is seldom an altogether easy life in Alaska. People talk about cheating death, but accident rates here are among the highest in the United States. Listen long enough to a Native elder—Tlingit, Haida, Tsmishian, Athabascan, Aleut, Chugach, Yupik, or Inupiat Eskimo—and you will likely hear a solemn litany of friends and family who have died: drowning, hunting, going too fast on a snowmachine or an all-terrain vehicle, drinking too much, being in the wrong place at the wrong time. Planes disappear. Boats go down. Hikers walk into the wild and never walk out. They make a mistake which might not be deadly, but if they panic and make another, and another, that's it. They're finished.

The first known Europeans to arrive in Alaska were Russian explorers in 1741. The commander of the expedition, Vitus Bering, was actually a Dane; and the expedition naturalist, Georg Wilhelm Steller, a German. Neither man made it back home. They sailed under the czarist flag and with a Russian crew. Those crewmen who did return home brought with them bundles of sea otter pelts—soft gold—that prompted a fur rush to Alaska. Russians arrived soon thereafter in makeshift boats, and they drowned by the dozens. But they managed to indenture Aleuts (Natives of the Aleutian Islands) to slaughter sea otters. Then came redemption, if such a thing were possible, in the form of Russian Orthodox priests who supervised the construction of churches in coastal Alaska, from Kodiak to Kenai to Sitka and Juneau (Saint Nicholas Church, built in 1894, left). Maritime disasters continued into the 1900s, with some of the worst in Lynn Canal, between Juneau and Skagway. Eldred Rock Lighthouse (opposite), first lighted in 1906 but now fully automated, still stands a lonely vigil to help guide mariners to safety.

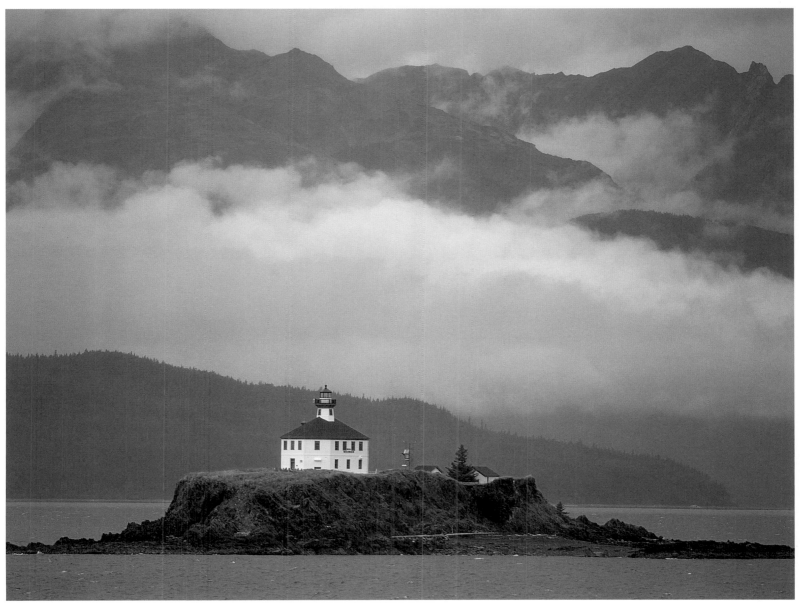

Eldred Rock Lighthouse and the Chilkat Range, Lynn Canal

Dog Days

Dog sledding is more than the official sport of Alaska, it is a way of life and a form of recreation. The country doesn't open up in summer, when tussocks and wetlands impede easy travel; it opens in winter when mushers and dogs can light out over snowy lands and frozen rivers. The Stampede Trail (left) invites a musher through April magic in Denali National Park, where rangers have patrolled by sled dog team since the 1920s. While a good racing team on a good trail can average seven miles an hour around the clock, larger freight-hauling dogs are much slower.

The most visible annual event in Alaska, the Iditarod Trail Sled Dog Race, has been criticized by animal rights organizations as frontier commerce that mistreats dogs. True, the dogs run hard. They are born to run because they are bred to run; humans have meddled in canine genetics for thousands of years and created everything from the border collie to the pit bull. Ironically, the best marathon sled dog in the world is not a pure breed, but the Alaska husky, light and fast, a descendant of village dogs raised along frozen rivers in Interior Alaska, with tough feet, strong appetites and a good disposition. Indeed, a few dogs die while racing, and some—though not many—are mistreated. Yet everyone agrees that dog care in Alaska has never been better. Mushers love their dogs deeply. Races large and small, formal and informal, famous and obscure, all bond communities by a common belief that if Alaskans can respect their dogs, they can respect each other.

Neki, a purebred Siberian husky (opposite, upper left), catches the last light of January at the Tozier Track, in Anchorage. Six-week-old Alaska husky pups play on a sled in Moose Meadow, in Girdwood (upper right). During the Copper Basin 300 Sled Dog Race, a musher and his team travel along the frozen Gulkana River (lower left) with 12,010-foot Mt. Drum in the distance. The 1,000-mile-long Yukon Quest International Sled Dog Race begins on the frozen Chena River in Fairbanks (lower right); it will end in Whitehorse, in Canada's Yukon Territory. Alternate years the race runs the other way, ending in Fairbanks.

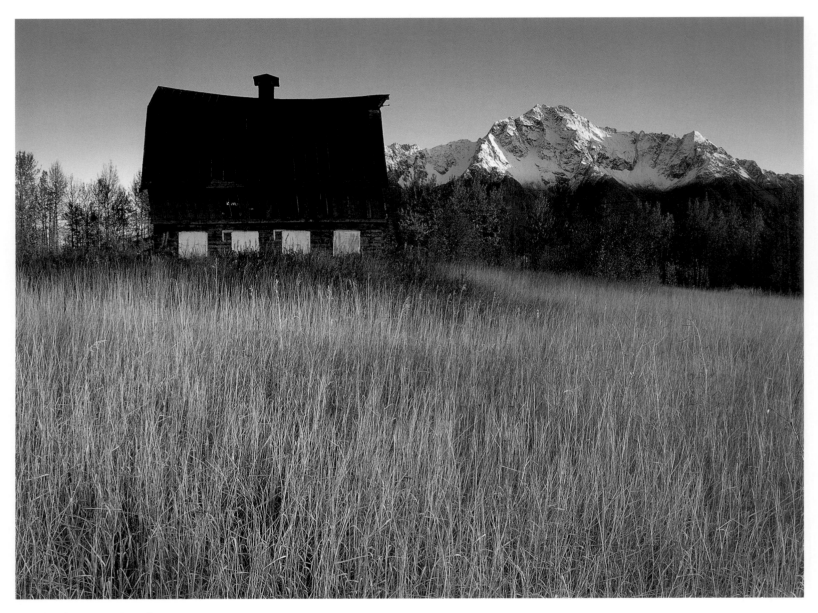

Old colony barn, Matanuska Valley

THE VALLEY NEXT DOOR

Half of all Alaskans live in Anchorage, which pundits say is only forty-five minutes from Alaska. To escape, many residents head east into the Chugach Mountains and Chugach State Park, or they drive southeast down Turnagain Arm to Girdwood and Portage Lake. They often continue south to Seward, Homer, and other favorite spots on the Kenai Peninsula. Every June they crowd the Kenai and Russian rivers and stand shoulder to shoulder on the eroding banks to "combat fish" for king salmon. Other escapees head north. Those who slow down and turn off the highway find the magic of the Matanuska Valley. They take a lazy road, turn left on an impulse, then right and left again, and soon a namelss pond comes into view, graced by an evening rainbow (right). Or an old colony barn stands in mute testimony of hard work in the 1930s (opposite), when pioneering families arrived to make a new life in the north. The peak behind the barn is in fact called Pioneer Peak. Today, the Matanuska Valley accounts for 52% of Alaska's farm production, with its 115-day growing season. The Tanana Valley, near Fairbanks, with twice the acreage but only a 90-day growing season, accounts for 43% of the state's agricultural output.

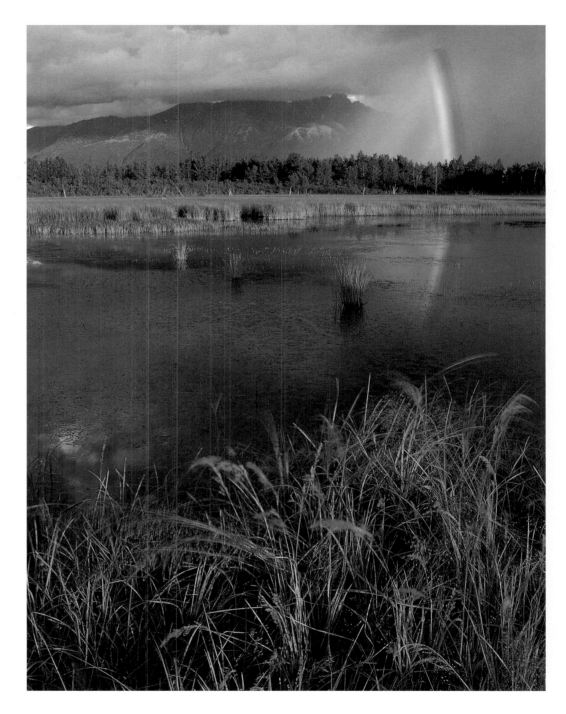

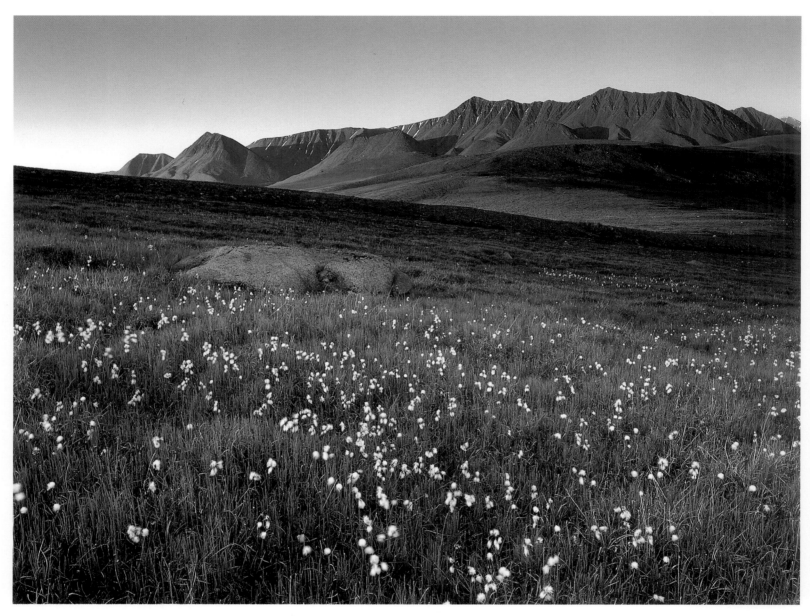

Cottongrass, Jago River Valley, Arctic National Wildlife Refuge

Frontier Rhetoric

You don't need to say Alaska is profound. Just say Alaska.

Just say a state—and a state of mind—larger than Texas, California, and Montana combined. Just say 33,000 miles of coastline (more than the contiguous United States); 100,000 glaciers (give or take a dozen); Jack London and *The Call of the Wild*; Robert Service and *The Cremation of Sam McGee*. Just say Saudi Alaska; a state operating budget funded 85 percent by oil taxes and royalties; and a state permanent fund (savings account generated from oil royalties and investments) that ranks higher than most Fortune 500 companies and pays each resident a dividend of more than $1,000 a year. Just say the strongest earthquake and largest oil spill in U.S. history. Just say *muktuk* and *mukluk* (the first is the outer skin and blubber of bowhead and beluga whales, a delicacy among Eskimos; the second is a boot made with bearded seal skin and caribou fur, or moose hide, and trimmed with beadwork). Just say more than 3,000,000 lakes and 7,000 wolves; the Iditarod Trail Sled Dog Race that runs 1,160 miles from Anchorage to Nome; 65 percent of the acreage in the U.S. National Park Service system; 88 percent of the acreage in the U.S. National Wildlife Refuge system; the northern-, western- and easternmost points in the U.S. (because the Aleutian archipeligo sweeps like a mammoth's tusk 1,200 miles across the Bering Sea and Longitude 180, crossing from west to east). Just say 17 of the 20 highest peaks in the U.S, but beware that five of those peaks are on Mt. McKinley: the South Peak (highest point in North America, 20,320 feet), North Peak, South Buttress, East Buttress, and Browne Tower. All are higher than fourteen thousand feet (and higher than California's Mt. Whitney, the highest point in the Lower 48 States).

Just say grizzly bears and the last frontier, as if somehow it will always be just that: a frontier.

Alaska's wildness and inaccessibility are what define it and protect it. Were it easy to reach, and safe and predictable, it wouldn't be Alaska anymore. It would be AlaskaWorld, a theme park full of fun and nature and guarantees, perfect for tourists, but anathema for travelers. Scenic yes, wild no.

Grizzlies don't thrive in scenery; they thrive in wildness. They live with a freedom and authority they cannot lose without being lost. They exist for reasons other than our pleasure in seeing them, yet their existence now depends on us. Extinct in California, endangered in Montana, for the grizzlies Alaska is not the last frontier, but the last chance; the only place (aside from parts of Canada and Siberia) where they can move from horizon to horizon and never cross a road or human scent.

But if Alaska is indeed the last frontier, what happened to all the others? Kentucky was a frontier once, wasn't it? And New Jersey and Florida and Colorado and California and Michigan?

Historian and Pulitzer Prize-winning writer Wallace Stegner reminds us that wilderness, once our parent, has become our dependent. Lose it and we lose not only grizzlies and wolves and wolverines and widgeons, but an important part of ourselves. Severed from our roots, we blow over in any storm. We become something that came from nothing, a people without a past, a drum without a beat, a story without a beginning. Our music will no longer be the April songs of chickadees; we will become cogs in our own machinery, children of the silicon chip more adept at communicating in cyberspace than in real geographies.

In the woods and mountains we speak and laugh with organic honesty. We breathe the distance and touch an intimacy and feel whole again. But we also learn that while frontiers bring out the best in some people, they bring out the worst in others. One man's tonic is another man's temptation.

"You just can't let nature run wild," said Walter Hickel, governor of Alaska, when asked why he approved aerial wolf hunting in the early 1990s. Hickel wanted to reduce the numbers of wolves and raise the numbers of moose

and caribou (preyed upon by wolves) that would be available to hobby hunters from Anchorage and Fairbanks. A few years later, Alaska State Senator Bert Sharp denounced wolf populations as "predator pits" that usurped caribou from his constituents who had hunted them for decades, and called for intensified predator controls that would kill up to 75 percent of the wolves in some areas. Fifty years earlier Aldo Leopold, father of the modern science of wildlife management, said hunting was a slow, crude tool compared to the precision instrument of predation that had shaped wildlife populations for millennia. But Hickel and Sharp don't read Leopold.

"It's not the last scenic view," said State Representative Walt Furnace when asked about potential logging in Kachemak Bay. Would he deface Alaska from one corner to another until there was indeed only one last scenic view? "A flat crummy place," said Harold Heinze, president of ARCO ALASKA, when asked about the Coastal Plain of the Arctic National Wildlife Refuge. If it's flat and crummy, well of course, drill for oil. What else is it good for?

The last frontier is not Alaska or outer space or genetics or computers or the human brain, it's our values. After the creation and detonation of the first atom bomb, Albert Einstein said, "We have changed everything except our way of thinking."

There are many Alaskans who believe every job is an appropriate job, and hard work its own virtue, and nature the empty canvas on which they will write their superior legacy. There is nothing new in the way they think. Their forebears paved Manhattan and fenced Texas. Their frontier rhetoric is not a window, it's a mirror. It confers upon them a sad absence of connectedness, and a tired appraisal of progress. On the finest day of spring they huddle indoors to plot another road, another pipeline, another clearcut and oil patch, while somewhere in Alaska chickadees sing, wolves howl, and a lone grizzly emerges onto the snowy tundra of a familiar place, roadless and pure for one more year, the only world she has ever known. ❧

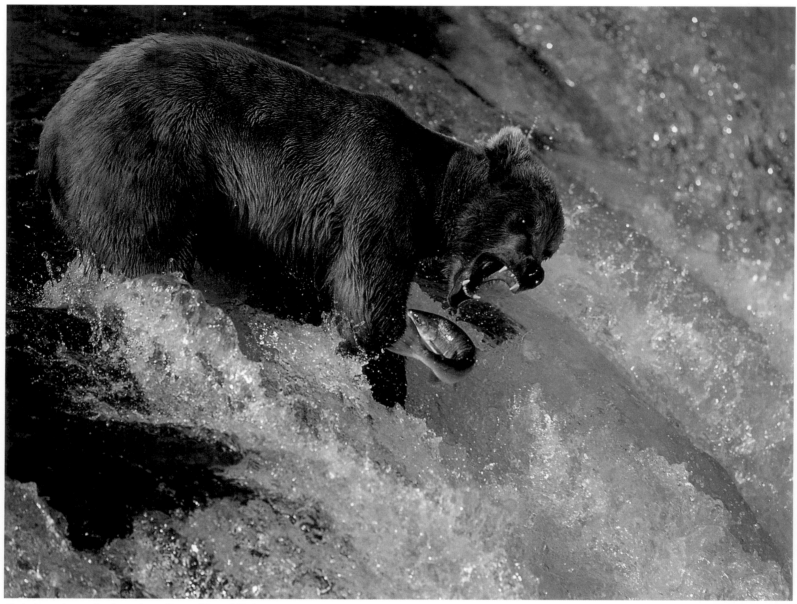

Alaska brown bear and sockeye salmon, Katmai National Park

KATMAI BEARS

"What was that bear doing out there? Where was he going?" The man asking the questions was a photo editor in New York City. The impression the bear made on him was as indelible as its tracks in the wet volcanic ash of the Valley of Ten Thousand Smokes, in Katmai National Park (right). "Why would a bear be in such a desolate place? Without berries or fish or other foods?" The editor knew that prior to June, 1912, the valley was filled with vegetation. But that changed when a cataclysmic volcanic eruption (many times more powerful than the 1980 eruption of Mount St. Helens) shook the area. The summit of Mt. Katmai collapsed, and seven cubic miles of incandescent ash burst out from a side vent, Novarupta. The valley filled with ash, and for many years after contained a vast array of fumeroles—volcanic steam vents (not smokes)—that inspired its name, given by Robert Griggs, a botantist who led an early National Geographic expedition into the area.

"Shouldn't the bear be near lakes and rivers, feeding on salmon?" the editor asked. Maybe, but bears are bears. They snub predictability. They embody wildness and mystery. That's their beauty. A bear might stand atop Brooks Falls and catch leaping salmon in midair (opposite). It might snorkel underwater, face down in the river, fishing. It might climb a mountain, nap on the summit, walk down the other side, walk to the coast, swim to an island. The editor thought about this and said, "I've lived in Manhattan for thirty years. I have a ten-year-old daughter, and my wife just died of breast cancer. I would like to bring my daughter to Alaska and show her a bear. I'd like her to see this world you talk about, show her there's something out there bigger and more honest than zoos and television and computer programs filled with digitized, fictional images. That's my dream. I want to fill her with awe and show her a wild bear."

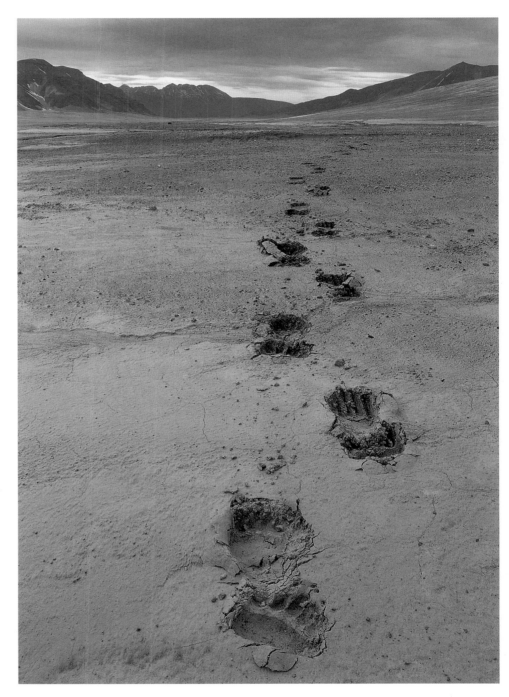

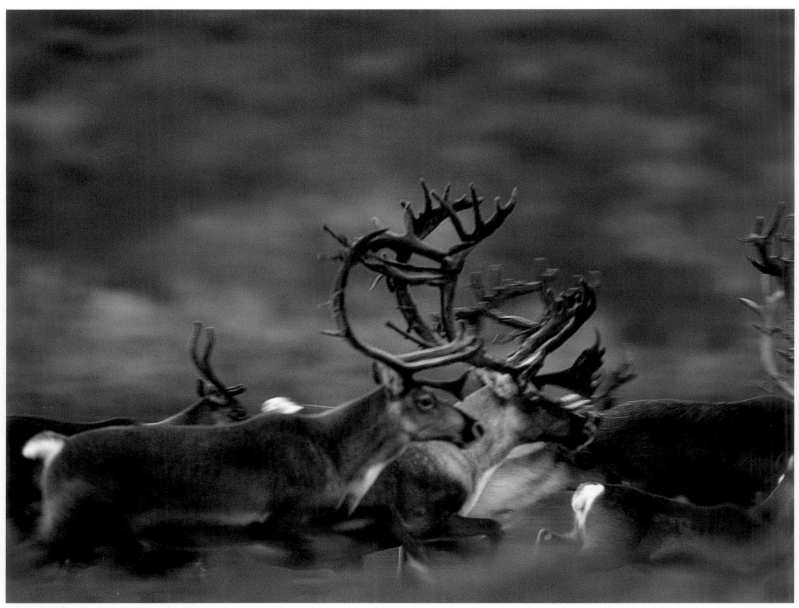

Running caribou, Kobuk Valley National Park

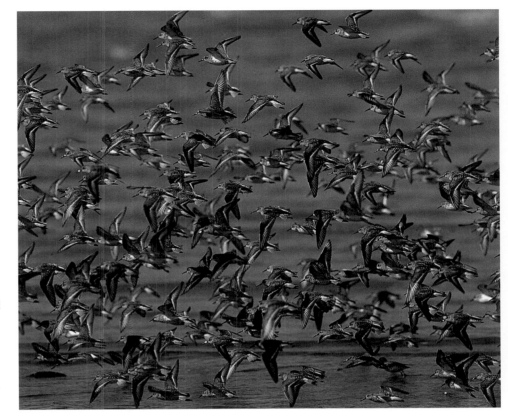

MIGRATIONS

A flock of western sandpipers takes flight (right)—
as sudden and powerful as snapping a sheet. Whoosh!
They dip and dart and create their own wind, ten thousand
birds now white, black, then white again against the
shore, their colors changing with each powerful turn,
choreographed by an unseen hand. They alight with wings
aflutter to feed on the tide flat. Then with no warning—
whoosh—they're up again, flaunting their aerial supremacy.
They winter on the coasts of California and Mexico, and
summer on the tundra of arctic and subarctic Alaska where
they raise their young. Equally important are their staging
areas—Grays Harbor in Washington State; the Stikine
River delta (near Wrangell) and Copper River delta (near
Cordova) in Alaska—where they arrive en masse in early
May to feed before continuing north.

For most birds in Alaska, migration is the rule, not
the exception. Most terrestrial mammals, on the other hand,
do not migrate (although some have shifting home ranges).
A strong exception is the caribou (opposite), where herds
travel between summer breeding grounds and winter feeding
areas. Caribou herds also fluctuate in size, some of them
dramatically. The Western Arctic Herd, which numbered
75,000 animals in the 1970s, exceeded half a million in the
1990s. At the same time some other herds declined. The
factors that cause these fluctuations are not yet fully
understood, and may not be for a long time.

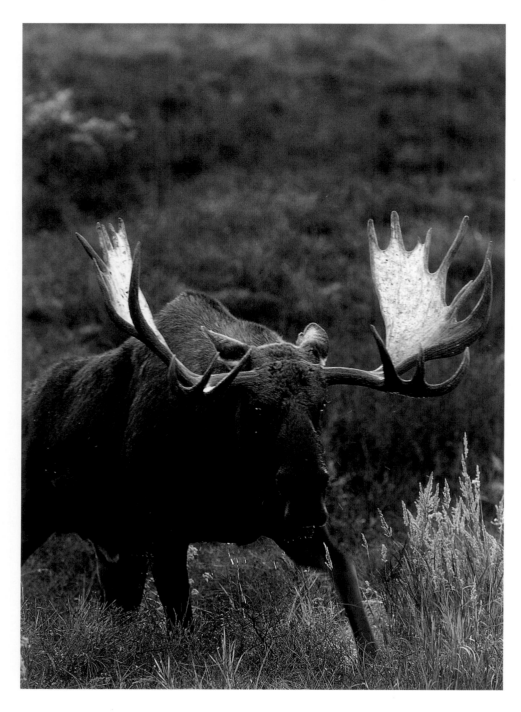

A NOBLE FORM OF WILDLIFE

No member of the deer family is larger than the moose, and no moose is larger than an Alaska moose, with bulls (left) weighing upwards of 1,600 pounds, including 70-pound antlers that spread seven feet, and cows (opposite) that weigh 1,000 pounds. Little wonder that pioneer naturalist/hunter Charles Sheldon, who explored the Denali region in the early 1900s (and worked tirelessly to make it a national park) wrote that "The sight of moose..." inspired in him "the consciousness of a noble form of wildlife."

Moose calves are born in late May and early June, often as twins, and develop quickly. Standing on long, wobbly legs, they weigh 28-35 pounds at birth, but can reach over 300 pounds in five months. Predation by bears and wolves can be high, much higher in fact than scientists once believed. Of all moose calves born in the eastern end of Denali National Park each spring, 85 to 90 percent die by autumn. Humans take a toll as well. In one difficult winter, 384 moose were killed on the Alaska Railroad, smashed by powerful locomotives and thrown aside the tracks, where they had gathered to move free of deep snow. Autmobiles kill upwards of 200 moose each year on the Kenai Peninsula. And most divisive of all, hunters argue over moose, and who among them—subsistence or urban sport hunters—should have a preference or an even allotment. Alaska has roughly 140,000-160,000 moose, with local populations always in flux. What moose need above all else is good habitat. But in a world of global greenhouse effects, destabilized climates, melting permafrost and a constantly growing, expanding human population, even that is in flux. Even habitats have mortality.

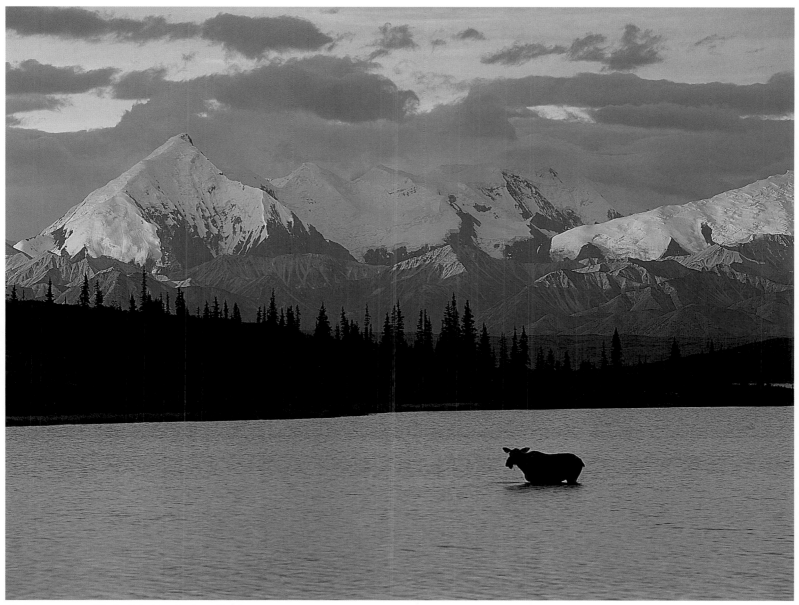

Alaska cow moose in Wonder Lake, Denali National Park

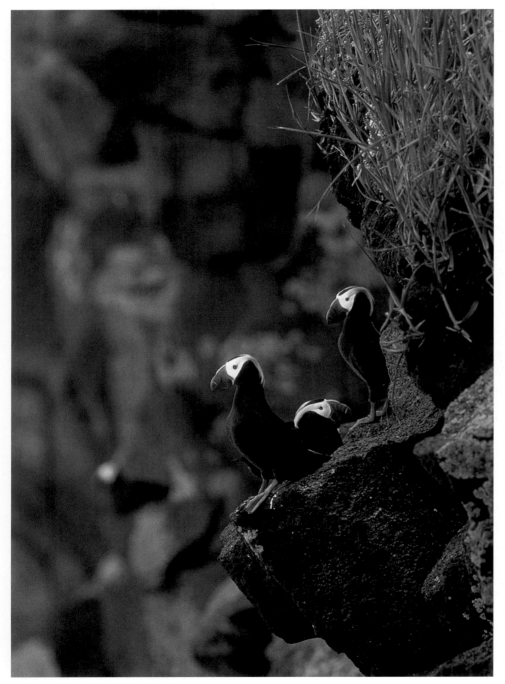

BIRDS OF A FEATHER

Draw a map of every bird that migrates to and from Alaska and their routes, like the spokes of a wheel, will radiate around the world to wintering grounds in Asia, Europe, Hawaii, Mexico, Panama, Patagonia, even Antarctica, a 22,000-mile round-trip made each year by the arctic tern. The Arctic National Wildlife Refuge alone hosts summer breeding birds from every other state in the U.S. Alaska is a huge nursery and avian melting pot for North American birds. As many as 247 species breed here; more than 430 species have been observed.

Tufted puffins (left) occupy sea cliffs together with other seabirds: auklets, cormorants, kittiwakes, and murres. While the others lay their eggs on narrow ledges, puffins nest in deep burrows excavated in soft soil at the tops of cliffs. Puffins must work hard to fly (harder for example than gulls and terns) but their heavy bodies enable them to dive and swim underwater in pursuit of small fish. In winter, they lose their ornate breeding dress—the white tufts and colorful keratin plates on their beaks—and go to sea amid storms and waves.

A semipalmated plover (opposite, upper left) pauses near its nest in the Arctic National Wildlife Refuge, in the far northeast corner of Alaska. After breeding here, it will winter in coastal areas of southern California, Mexico or Central America. A male Barrow's goldeneye (upper right) appears unperturbed by the ubiquitous rain of Southeast Alaska. This diving sea duck typically breeds on inland summer lakes, and spends its winter in coastal areas. A white-crowned sparrow (lower left) perches in a spruce tree in Interior Alaska. A female northern pintail (lower right) is a light-bodied duck that dabbles rather than dives, and erupts from the water into sudden flight.

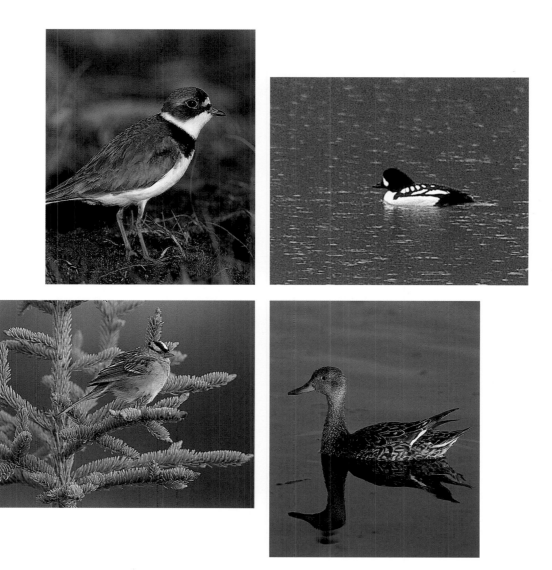

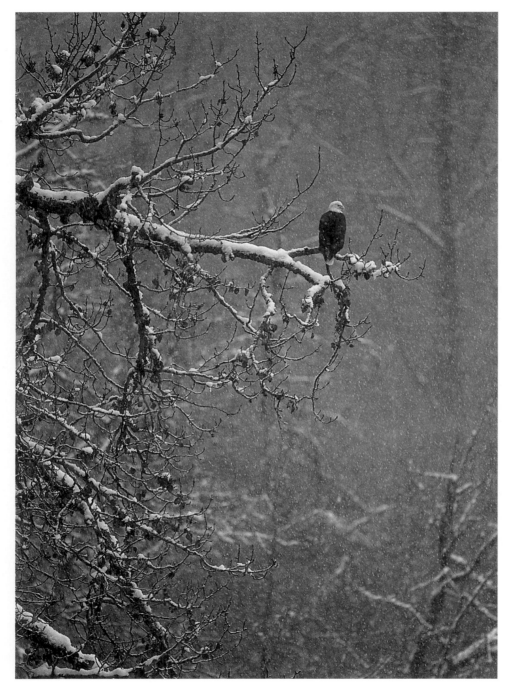

How to Rescue a Raptor

Raptors are birds of prey: owls, eagles, hawks, falcons, kites, ospreys, and others that make their living with lethal talons, sharp beaks, and sharper eyes. Owls in Alaska pounce on rodents, as do golden eagles. Golden eagles also dive at Dall sheep lambs and knock them off cliffs so they fall to their deaths and make a full meal. Bald eagles perch in shoreline spruce, hemlock, and cottonwoods. Taking flight, they swoop down and rake their talons into the sea to catch salmon. More typical, however: they gather along streams and rivers to feed on dying, spawned-out salmon.

Every November–December somewhere between 1,000 and 4,000 bald eagles gather along the Chilkat River, near Haines, to feed on a late run of chum salmon. They perch in majestic cottonwoods (left) amid falling snow, where people come from around the world to see them, and Haines holds an annual festival to celebrate them. But in the 1970s contentious debate simmered over the fate of this area. Conservationists (together with Governor Jay Hammond) wanted it preserved; loggers (supported by the State Legislature) wanted the cottonwoods cut. The issue gained national attention, and careful negotiations followed.

Finally in 1982, 200 years after the bald eagle was chosen the national symbol of the young United States of America, the 48,000-acre Alaska Chilkat Bald Eagle Preserve was established. Two years earlier in Sitka, other bird enthusiasts founded the Alaska Raptor Rehabilitation Center, which today treats more than fifty injured bald eagles a year, plus many other birds and mammals. Most are released back into the wild. Those with permanent injuries, such as Hoot, a northern barred owl (opposite), find a permanent home in the Center and become mascots for the noble cause of raptor rescue.

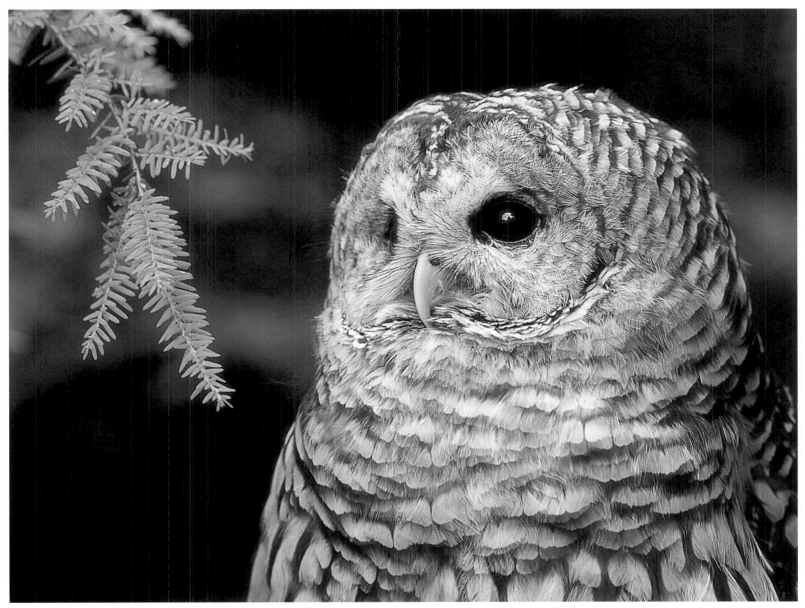

Northern barred owl, Sitka

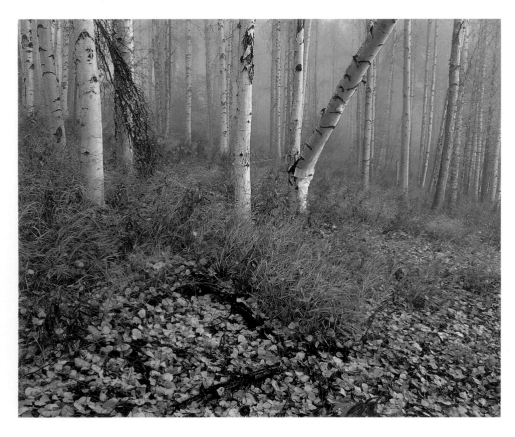

AUTUMN, BRIEF BUT BRILLIANT

Oldtimers like to say that Alaska has only two seasons, winter and July. Autumn can actually last a couple weeks, but might also last only a couple days before a strong wind blows off the leaves, or an early storm drops three feet of snow that doesn't melt until May. The tundra turns russet, red and orange, the aspens gold, the birches yellow. This happens in mid-August in the arctic; in late August and early September in the Interior, and in mid-September around Anchorage and southcentral Alaska. An early heavy snowfall can catch the birches and aspens in full foliage. The leaves cradle the snow and bend the trees to the ground. Many break under the weight; others remain bent over for years.

Because cold air is heavier than warm air, it sinks to valley floors on chilly autumn mornings and creates fog that filters through forests of birch (such as in White Mountains National Recreation Area, near Fairbanks, left). At the east end of Denali National Park (opposite), birches, aspens, blueberry, soapberry, dwarf birches, and Labrador tea make a handsome montage with dark spruce and cloud shadows on distant peaks. The first snow on higher slopes is called termination dust by Alaskans. It signals the end of summer. Time for tourists to leave. Time to put away fishing pole and kayak, dig out skates and skis. Dust off that novel you've wanted to read, or write. Winter is coming: the long, dark tunnel that seems to last longer every year. Thank goodness for good friends who will share it, shorten it, and make you laugh.

Autumn palette, Denali National Park

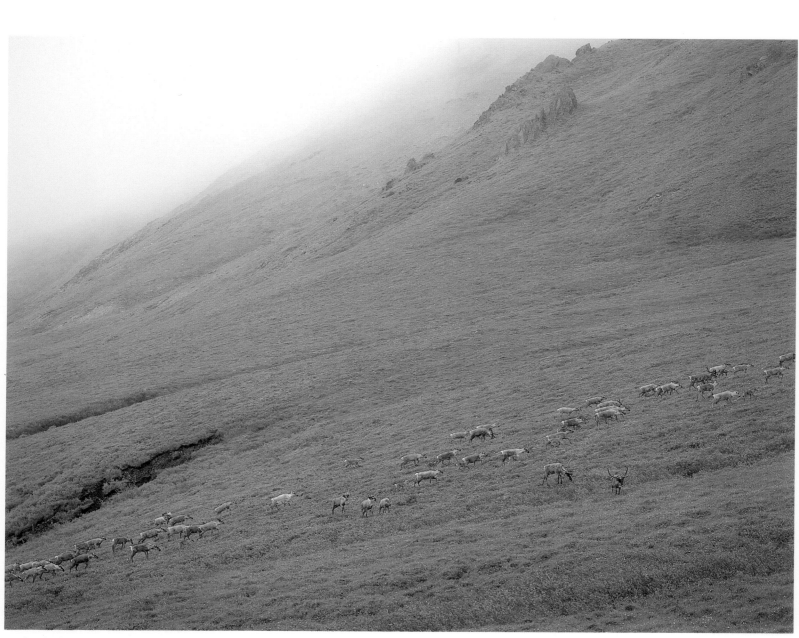

Caribou (of the Porcupine Caribou Herd), Arctic National Wildlife Refuge

90

Caribou Dreams

The man from Philadelphia is in the kitchen smoking a cigar. He wears a thin smile that suggests he knows something nobody else does. This would be true in the city, because there he is well-connected; a man of wealth and influence. He captains a corporation and knows the bottom line. He makes things happen. But not here. Here things happen to him. Here he camps on the tundra and breaks in new hiking boots, and the crazy sun stays up all night, and the kitchen is a makeshift shelter set amid willows and wildflowers in Alaska's Arctic National Wildlife Refuge. Here passersby are caribou, bears, jaegers, and plovers pulsing to a metronome thousands of times more ancient than any gleaming, grimy metropolis. Here things don't make a living, they live.

So why the smile?

When he first arrived three days ago, the man from Philadelphia didn't sleep well. The ground was too hard, the air too cold. He missed his Wall Street Journal and he worried: Did I make a million dollars today, or lose a million? He and three friends (all corporate men from back East) journeyed here because one of them has a daughter who works for a conservation organization in Fairbanks. She asked if they would visit the refuge and, if inspired by its grandeur and beauty, contribute to its protection.

I met them on their first day, when a stiff crosswind blew their bush plane into crablike motions as it landed on a gravel strip next to the Kongakut River. The pilot—wearing a T-shirt, tennis shoes, and an aw-shucks grin—said a large aggregation of caribou was to the west and moving our way. They might come through here in a day or two. Then again, they might go farther to the north or south. Hard to tell. That's caribou, he said, they go where the winds blow them. He fueled his plane and said he had to get back

to his other job: emergency room doctor in Fairbanks. We watched him fly away into the teeth of the Brooks Range. The man from Philadelphia asked where the rest room was. Somebody pointed to a willow and said, "Behind there."

The next two days we saw a few caribou, a dozen here, a dozen there, maybe 200 total. They came from the west—bulls, cows, and calves—and hesitated on the banks of the Kongakut, and plunged in. The swift current carried them downstream, but they swam boldly, the calves close to their mothers. Reaching the other side, they shook themselves and bounded upslope with what could only be called exuberance.

We were thrilled to see this, but it was only a prelude, for on the third day the caribou came in numbers we could not have imagined, a procession from a Kipling fantasy, a great northern Serengeti, waves upon waves of caribou passing by so near that we could hear their cryptic voices and clicking hooves. Biologists would later tell us the number was close to 100,000. For fourteen hours they streamed by, as if they, too, like the Kongakut, were a river.

This is why the man from Philadelphia now smiles and smokes his cigar. He has seen one of the greatest wildlife wonders on the face of the earth. "If only every American could see what we have seen," he says. "They would never allow oil drilling where these animals give birth to their young. People from Congress need to come here."

I tell him a story: A few years ago some photographers were in the Refuge when a helicopter landed in their camp with several congressmen on board. The congressmen had come north to see the refuge for themselves, and were being shuttled around courtesy of an oil company. The photographers told the pilot that a large aggregation of caribou had come through a few hours ago, and must be only a few miles to the east, if he wanted his distinguished passengers to see them. The pilot loaded up his passengers and flew in the opposite direction. A few days later, the photographers saw the pilot

in the Eskimo village of Kaktovik, and asked him why he didn't fly the congressmen to the caribou. The pilot said he had been told to do his best *not* to show them the caribou.

The man from Philadelphia nods and says, "Corporations sell products, but they buy people. I know. I've done it for thirty years." He puffs on his cigar, thinks a bit. "Did you know that when Meriwether Lewis saw the plains of eastern Montana filled with antelope and buffalo in 1805, he said it reminded him of sheep in Virginia? It was his only reference. Now look at Montana. It isn't filled with antelope and buffalo anymore, it's filled with cattle and sheep."

"His reference was a prophecy?"

"I guess so." He shakes his head. Offers me a cigar. No thanks.

We talk about the EXXON VALDEZ and Prince William Sound. He says, "It's too bad we don't respond to processes like we do to events. We recoil from the shock of an oil spill, but are blind to a thousand little leaks. We jump from the thunder of a landslide, but remain deaf to the whisper of erosion."

"Both destroy pristine Alaska."

"Ah yes," he raises his cigar like Sherlock Holmes with his pipe, "but it's the incremental stuff—what they call 'progress' and we call erosion—that's the most insidious."

I tell him that I'm going to have caribou dreams that night.

"Caribou dreams?" He arches his eyebrows and puffs away. "That sounds marvelous."

We bid goodnight and collapse into our tents, exhausted. The next morning I don't hear the plane until it's taking off. Wearing longjohns, I jump from my tent and run to the strip in time to see the little Cessna lifting into the sky. In the back seat is the man from Philadelphia. He waves and gives me a thumbs up. I wave back, and watch the plane until it disappears to the south, into the immensity of mountain, river, and sky. ❧

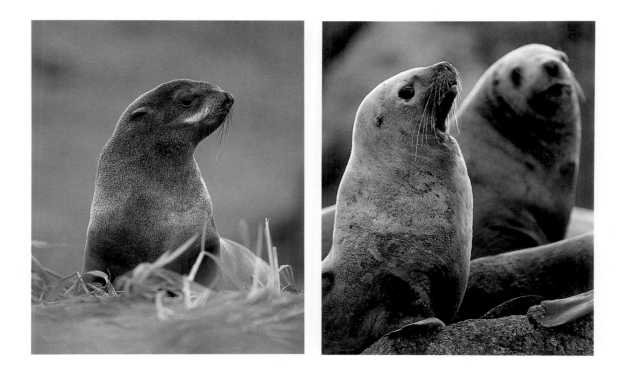

Fin Foots

Seals, fur seals, sea lions, and walruses belong to an order of marine mammals called *Pinnipedia*: Latin meaning "fin foot." Able to swim with great agility and dive hundreds of feet in pursuit of fish and squid, they come ashore (usually on islands) to give birth, mate, and molt. The northern fur seal (above left) and Steller sea lion (above right) belong to the family *Otariidae*. They have external ears and can rotate their hind flippers forward to "walk" on land. Males weigh about four times more than females, and collect harems. True seals, such as harbor seals, belong to the family *Phocidae*. Males and females are roughly the same size, and cannot prop themselves up on their front flippers. They rest on their bellies and wriggle to move, and often give birth to their pups on icebergs. In many parts of Alaska harbor seals and Steller sea lions are in decline. Northern fur seals, slaughtered for their skins for more than a hundred years, have rebounded, but still remain threatened (in their breeding grounds on the Pribilof Islands, see p. 50) by global climatic changes and intense human fisheries.

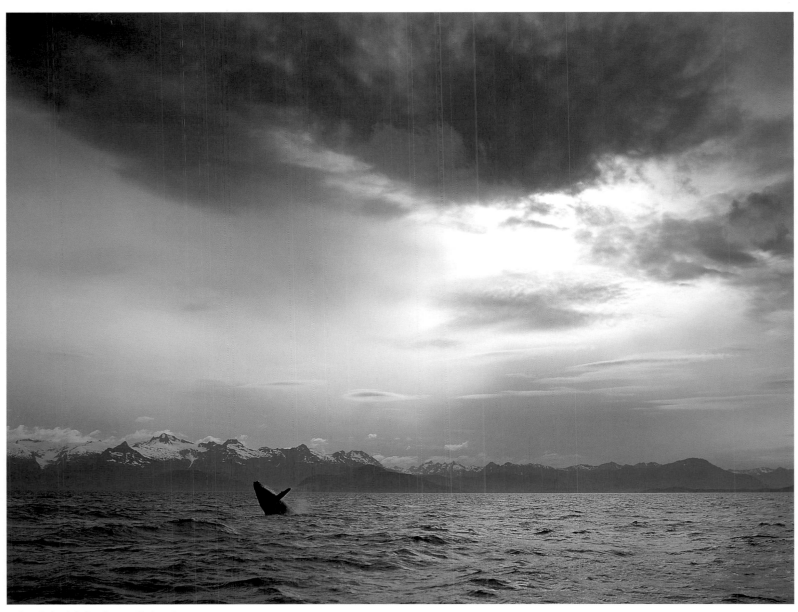

A humpback whale breaches in Chatham Strait

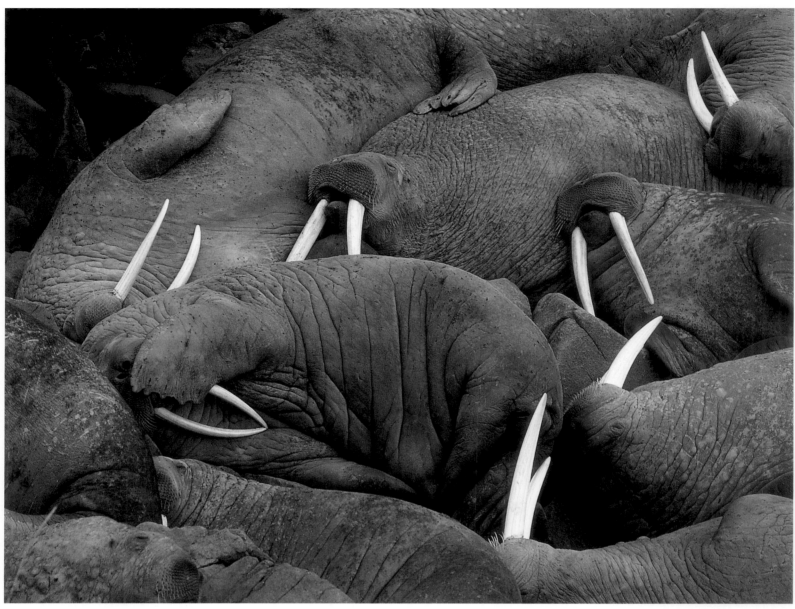

Pacific Walruses, Round Island, Walrus Islands State Game Sanctuary, Bristol Bay

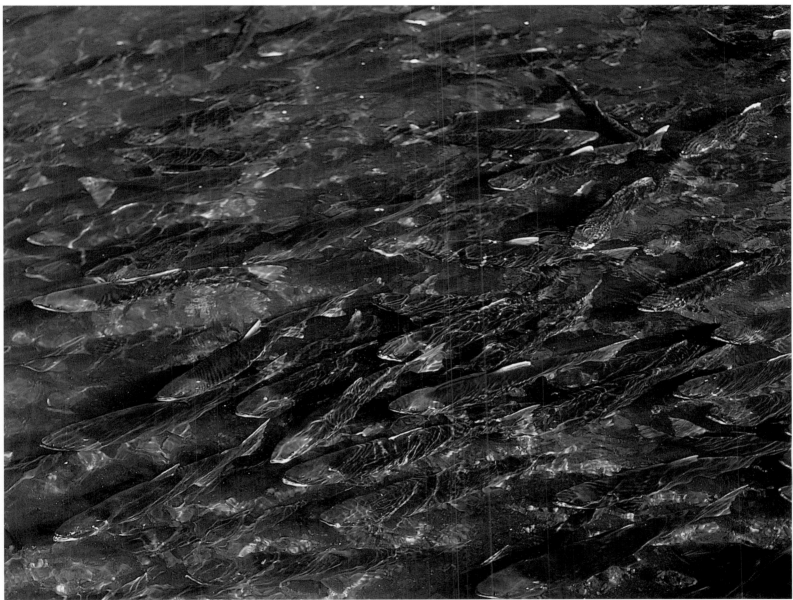

Spawning sockeye salmon, Egegik watershed, Alaska Peninsula

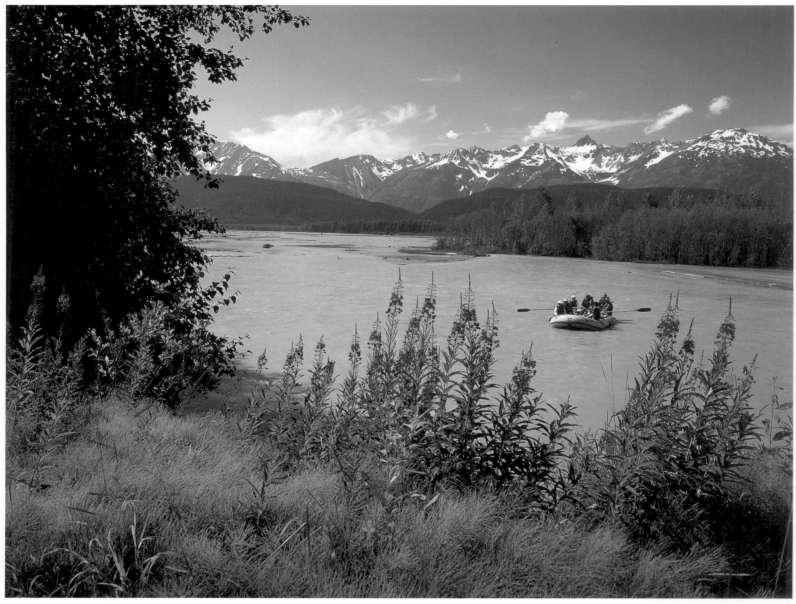

Rafting the Chilkat River, near Haines

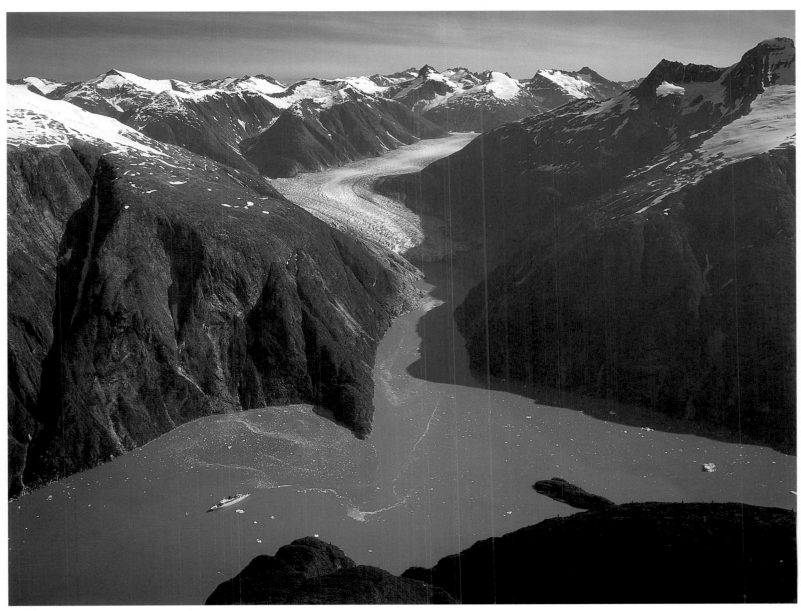

Cruise ship in Tracy Arm, Tongass National Forest

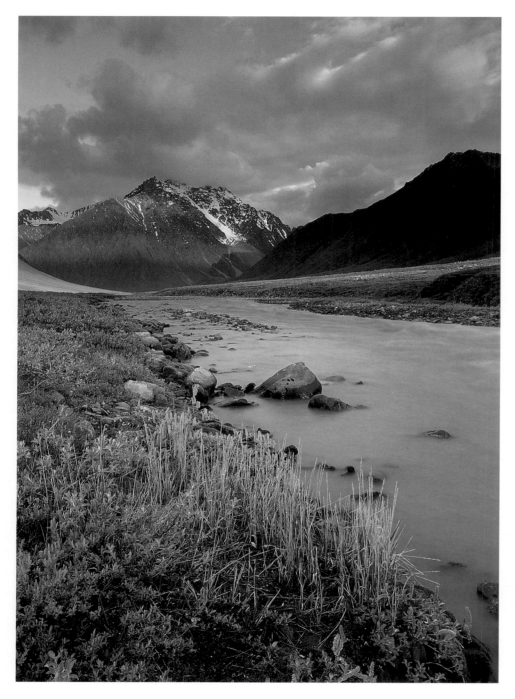

RIVER TAKE ME AWAY

If the measure of a good river is its ablity to flow through both land and soul, to run clear, quiet, tumbling or turbid, yet always intoxicating somehow, always whispering, *Follow me; I know something about you even you don't know...* then Alaska's rivers are among the best. The more we leave them unchanged, the more they change us. Songwriter Bill Stains sings:

> *River take me away,*
> *in the springtime, changing and free.*
> *In the moonlight, wild and so free,*
> *you rolling old river, you changing old river,*
> *let you and me river go down to the sea.*

There are 26 designated wild and scenic rivers in Alaska, and a dozen more on a list for consideration by Congress. The mightiest of Alaska's rivers is the Yukon (opposite, filled with ice during spring breakup). The Yukon has its headwaters in Canada. It enters eastern Alaska near Eagle, flows 1,400 miles west through the state, and empties into the Bering Sea. After freezing every winter, it thaws every spring and fills with great blocks of ice that raft downstream and crash into each other.

Rivers north of the Brooks Range, such as the Jago (left) in the Arctic National Wildlife Refuge, flow north into the Beaufort Sea. Midnight amber light paints this Arctic landscape in summer, while darkness entombs it in winter. If the oil industry gets its way and drills in this refuge, the Jago (downstream of this photo) will someday flow through an industrial farm of well pads, roads, and pipelines, as charming as a gas station.

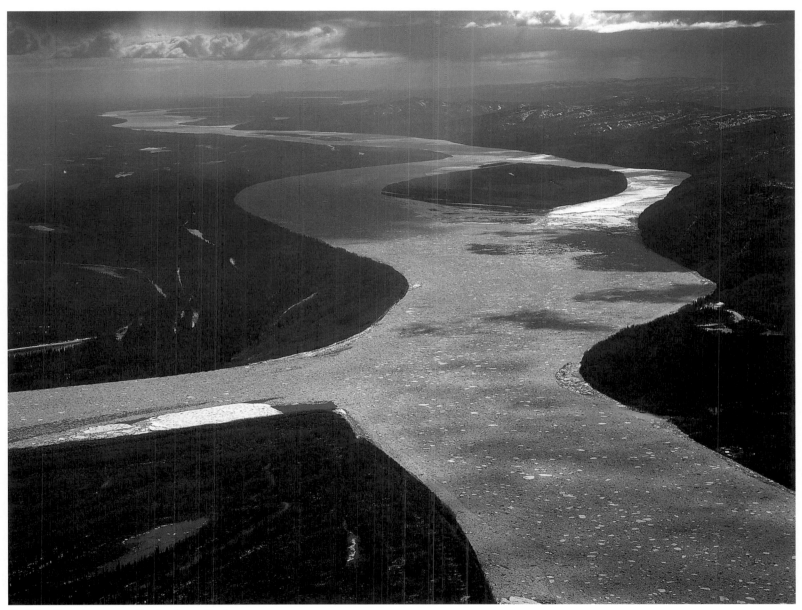

The Yukon River during spring "breakup," near Grayling

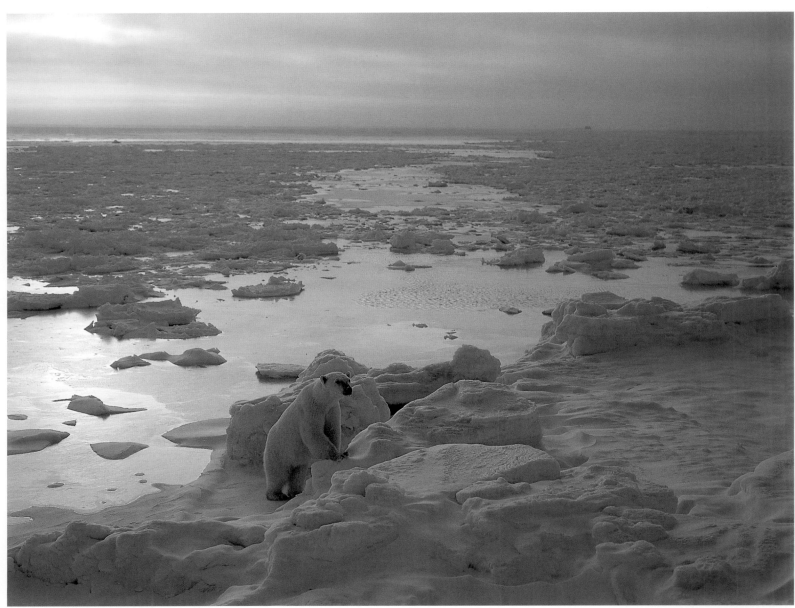

Polar bear, Cape Churchill, Manitoba

KATHY BUSHUE/ACCENT ALASKA

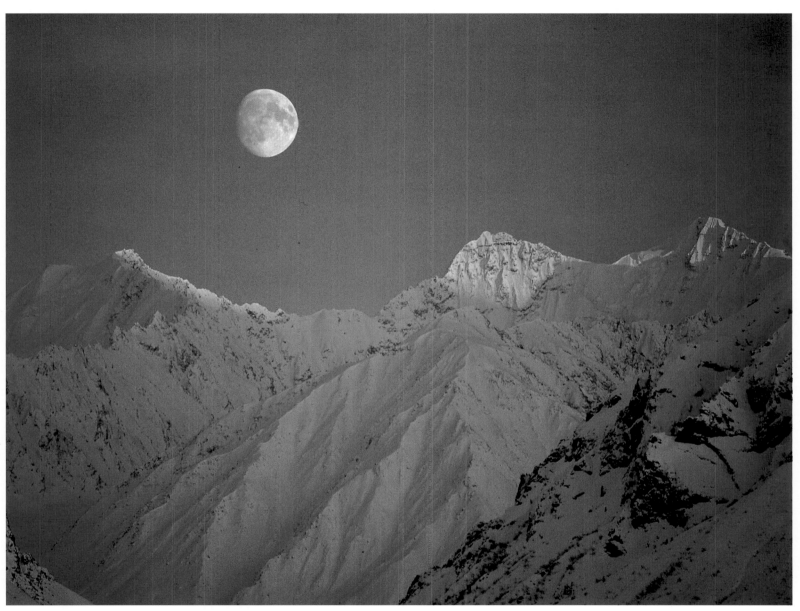

Moonrise over the St. Elias Mountains, Wrangell-St. Elias National Park

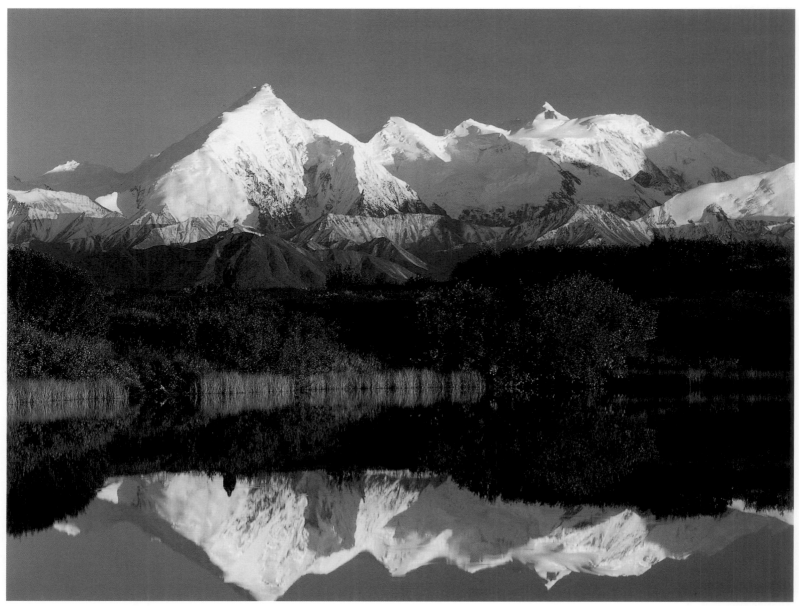

Mt. Brooks and the Alaska Range from Reflection Pond, Denali National Park

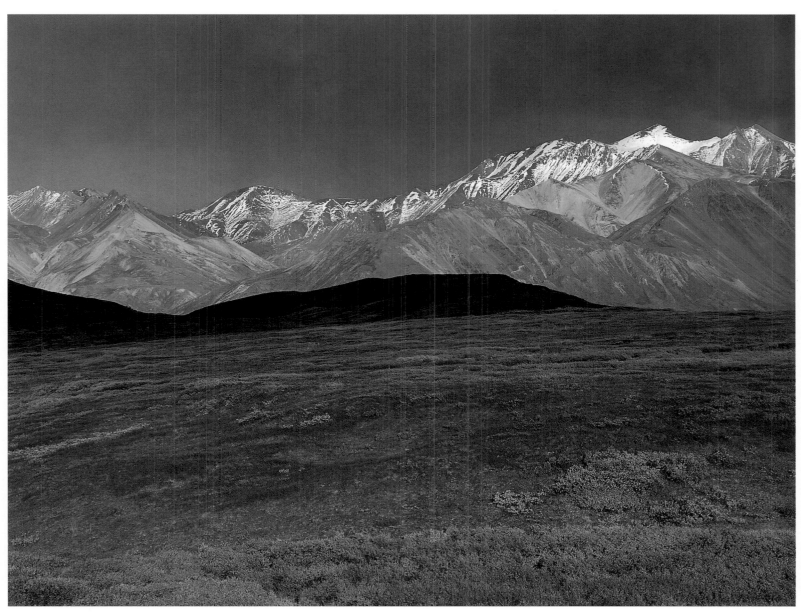

Autumn colors, Grassy Pass, Denali National Park

Lineages and Legacies
A TIMETABLE OF ALASKA HISTORY

c. 2,000,000 – 10,000 years ago

The Ice Age (a.k.a. Pleistocene epoch) dominates Alaska. Glaciers carve fjords, smother mountain ranges and shape much of Alaska's topography. The glaciation is discontinuous over time and area. Periods of extensive ice advance (over tens of thousands of years) are broken by periods of glacial retreat (also for tens of thousands of years) when the ice rivers shrink into positions similar to today. Some areas (called refugia) remain ice-free even during maximum glaciation: the Yukon River flats, Fairbanks area, and western arctic for example. Within these refugia live woolly mammoths, mastodons, saber-toothed cats, giant ground sloths, North American camels, and other mammals in the twilight of their existence. Early humans hunt them. (Scientists have found spear points in fossils). One by one the great mammals become extinct as the final period of Pleistocene glaciation peaks about 20,000 years ago, and habitats change. The great glaciers then retreat, and outwash sediments fill in deep fjords and bays. Turnagain Arm, once hundreds of feet deep, becomes a large mud flat at low tide. Mendenhall Flats, once a bay, now hosts the Juneau Airport.

c. 25,000 – 6,000 years ago

The first Americans arrive from Siberia by crossing a land bridge where the Bering Sea is today. The bridge is hundreds of miles wide, and exists because more of the world's water is invested in glacial ice, which lowers sea level as much as 350 feet. The hunter-gatherers move eastward mile by mile, generation by generation, following available foods. Some go overland, some along the coast, fishing and sealing. They are the ancestors of today's Alaska Natives: Aleuts, the skilled seafarers of the Aleutian Islands; Yupik and Inupiat Eskimos of western and northern Alaska, who prosper under conditions that would kill most other people; Athabascans of Interior Alaska, who migrate from one seasonal camp to another in pursuit of caribou; Tlingit and Haida of Southeast Alaska, who live close to the forest and the sea and develop arts and crafts to celebrate their bounty. Each ethnic group is distinct, with its own language. Trading is not uncommon between them. An estimated 80,000 Natives live in Alaska in 1740, the year before Europeans arrive. (By 1940, after 200 years of white men's diseases and subjugation, they number 40,000.)

1741

Europeans discover Alaska when Vitus Bering and Alexei Chirikof, sailing for Russia in two small ships (separated weeks earlier in a storm), land at Kayak Island and Lisianski Strait. Chirikof sends two boats ashore that do not return. After one week, two canoes approach his ship paddled by Tlingits, not rowed by Russians. From a distance a Tlingit in red regalia shouts to the Russians, waves them off and turns back to shore. Chirikof manages to sail home safely; the fate of his shore party unknown to this day. Bering flounders off Commandorski Island, midway between the Aleutians and Kamchatka, and dies there in December. His shipwrecked crew rebuilds the ship the following spring and sails home with bundles of sea otter pelts that fetch top prices on the Chinese market.

1742

Russians sail east from Kamchatka to begin harvesting sea otters and other marine life in Alaska.

1768

The Steller sea cow, a gentle relative of the manatee, first recorded by naturalist Georg Wilhelm Steller (who sailed with Bering in 1741), is hunted to extinction.

1778

Captain James Cook surveys the Alaska coast in search of the Northwest Passage, the fabled commercial trade route between Europe and Asia over the top of North America. Serving under him are Midshipman George Vancouver and Master William Bligh. Cook sails into Prince William Sound and names it for the nephew of King George III, the misguided monarch who unleashes the world's most powerful army and navy to fight 13 freedom-minded ragtag colonies on the other side the continent. Cook sails up Cook Inlet and Turnagain Arm, thinking he has finally found the Northwest Passage, but alas he has to "turn again."

1784

The Russians establish their first settlement in Alaska, at Kodiak, with 192 men and one woman.

1786

While lost in fog on the Bering Sea, Gerassim Pribilof, a Russian sailor/merchant, discovers the

islands where northern fur seals breed. (Russians later move indentured Aleuts to these islands to harvest seals.) On the other side of Alaska, Jean Francois de Galaup de LaPerouse sails into Lituya Bay and spends 26 days observing the grandest scenery he has ever seen. Tragedy strikes when two longboats are pulled into treacherous currents. LaPerouse buries a bottle on Cenotaph Island with a note inside: "At the entrance to this harbour perished twenty-one brave seamen. Reader, whoever thou art, mingle thy tears with ours."

1794

Captain George Vancouver surveys Alaska and sights Mount McKinley from Cook Inlet. Farther south, his chart of Glacier Bay (actually drawn by Lieutenant Whidbey) becomes a benchmark for the most rapid glacial retreat in written record. (The glacier that fills Glacier Bay will recede 60 miles in the next 120 years.)

1799

The Russian-America Company, under the leadership of Alexander Baranof and with the assistance of nearly 1,000 Aleuts, establishes a trading post at *Arkhangelsk Mikhailovsk* (Fort St. Michael, a few miles north of today's Sitka).

1802

Tired of insult and treachery, Tlingit warriors attack the Russians at St. Michael, kill many occupants and burn the post.

1804

The Russians retaliate by bombarding the Tlingits from a frigate. The Tlingits retreat. The Russians build their new capital at *Novoarkhangelsk* (New Archangel, today's Sitka).

1821

Father Ivan Veniaminov, a 24-year-old Russian Orthodox priest (who later becomes Bishop

Innocent of Kamchatka and all Alaska), arrives in coastal Alaska to bring moral discipline to the Russians, and conversion and education to the Natives.

1824–42

Russian expeditions travel up the Kuskokwim, Yukon, and Koyukuk Rivers to explore Interior Alaska. Sitka is for awhile the largest city on the west coast of North America; the "Paris of the Pacific."

1835

American and French whaling ships arrive in Alaska.

1867

With the sea otter hunted to economic collapse (and near-extinction), Russia sells Alaska to the United States for $7.2 million, roughly two cents an acre. Many Americans are critical of the seemingly wasteful expense in the aftermath of a costly civil war. The press dubs it "Seward's Folly" after Secretary of State William Seward, who negotiated the deal.

1869

The Sitka Times is the first newspaper published in Alaska.

1872

Minor gold rushes hit Sitka and Wrangell.

1879

John Muir travels to Alaska for the first time. His writings begin to educate America (and the world) that Alaska is more than igloos and iceboxes.

1880

Kowee, a Tlingit leader of the Auk Kwaan tribe, leads Joe Juneau and Richard Harris up Gold Creek to Silver Bow Basin, above Gastineau Channel, where they find a mother lode.

Harrisburg is born (the name is changed to Juneau the next year).

1882

After a dispute surrounding the unfortunate death of a Tlingit whaling captain, the U.S. Navy bombards the Tlingit village of Angoon, on Admiralty Island.

1883

Steamships (Alaska's first cruise ships) begin to visit the Inside Passage and Glacier Bay. Among the passengers is writer Elizah Ruhamah Scidmore, who renders the icy landscape into vivid images without embellishment.

1887

Anglican minister Father William Duncan leads the Tsimshians from British Columbia to settle in Metlakatla, on Annette Island, near Ketchikan.

1896

George Washington Carmack and two companions discover gold in great abundance on Rabbit Creek, a tributary of the Klondike River, in Canada's Yukon Territory. Dawson City is founded.

1897

Steamships arrive in Seattle and San Francisco carrying "tons" of gold. The news "Gold! Gold in the Klondike!" breaks the despair of a nation in economic depression, and sparks one of the largest human exoduses in modern times.

1897–1900

Tens of thousands of men—and hundreds of women—reinvent themselves to join (and create) the Klondike gold rush. Leaving their former lives behind, they travel by steamship up Alaska's Inside Passage to the lawless towns of Skagway and Dyea, then over the Chilkoot and White passes and down the Yukon River in makeshift

boats to Dawson City, Yukon Territory, Canada. Forests are leveled to build boats and towns. In Dead Horse Gulch 3,000 horses are driven to their deaths or shot outright by frustrated stampeders. Mounties require that each stampeder arrive in Canada with at least a ton of supplies. Some must trek 40 times back and forth over the passes to meet the requirement. Few strike it rich (all the good claims were staked in 1896 before the rush began). Among the northbound hopefuls is 21-year-old Jack London. (Years later, many stampeders say that despite its adversities and disappointments the gold rush was the greatest adventure of their lives.)

1899

Railroad magnate Edward H. Harriman fills a steamship with distinguished American scientists, naturalists, artists, writers, and photographers and travels to Alaska. Among the passengers is 61-year-old John Muir making his final trip north. Harriman wants to shoot a bear; Muir sends him across a glacier to "Howling Valley" where he knows Harriman will be unsuccessful. (Harriman eventually gets his bear on Kodiak Island; Muir is not impressed.) In September a strong earthquake shatters tidewater glaciers in Glacier Bay, filling the bay with floating ice so thick that ships can no longer navigate. The tour ship industry fades and doesn't return in earnest until the 1960s.

1900

The White Pass & Yukon Route Railway, Alaska's first railroad, is completed between Skagway and Whitehorse.

1902

Gold is discovered in Goldstream Valley. Fairbanks is founded. Alaska's first commercial oil discovery is made near Cordova.

1903

Jack London's *Call of the Wild* is published and becomes one of the most widely read novels in America. The Alaska-Canada Boundary is finalized.

1906

Peak gold production year in Alaska (from major strikes in Juneau, Fairbanks, and Nome). Alaska's capital city moves from Sitka to Juneau.

1907

President Theodore Roosevelt establishes the Tongass National Forest. Robert Service's *The Spell of the Yukon and Other Verses* is published to immediate success. It contains the poems "The Shooting of Dan McGrew" and "The Cremation of Sam McGee."

1911

Copper production begins at Kennecott, in the Wrangell Mountains. (It will peak in five years, exceeding Alaska's production of gold.)

1912

Congress grants Alaska territorial status. Mount Katmai erupts (from the Novarupta vent on its flank) and creates the Valley of Ten Thousand Smokes; day becomes night in Kodiak, 150 miles away, as the sky fills with volcanic ash.

1913

Hudson Stuck, Walter Harper, Harry Karstens, and Robert Tatum make the first successful ascent of Mount McKinley (highest peak in North America); Alaska's first airplane flight (in Fairbanks) and the first automobile trip in the state (Fairbanks to Valdez) are made.

1915

Anchorage begins as a wilderness tent town during construction of the Alaska Railroad.

1917

President Woodrow Wilson signs the bill that creates Mount McKinley National Park.

1918

Woodrow Wilson signs a presidential proclamation that creates Katmai National Monument.

1923

Warren Harding is the first U.S. President to visit Alaska. He drives a golden spike in Nenana (misses on the first swing) to commemorate completion of the Alaska Railroad (between Fairbanks and Seward). He also signs an executive order that creates Naval Petroleum Reserve Number 4 (later renamed the National Petroleum Reserve Alaska) on the North Slope.

1924

Noel Wein makes the first airplane flight between Anchorage and Fairbanks.

1925

In January a diphtheria epidemic threatens Nome, which is isolated by darkness and severe cold. Serum is sent by train from Anchorage to Nenana, and from there relayed by 20 mushers and their dog teams who cover 674 miles in five days and seven hours to save the stricken town. In February Calvin Coolidge signs a presidential proclamation creating Glacier Bay National Monument. The year before the *Juneau Empire* declared it a "monstrous proposition" that would curtail farming, grazing, mining, and lumbering all "to protect a glacier that none could disturb if he wanted or none would want to disturb if he could…the quintessence of silliness."

1929–31

Forester/conservationist Robert Marshall visits Wiseman, travels up the North Fork of the

Koyukuk River and names Frigid Crags and Boreal Mountain the "Gates of the Arctic." He proposes that all of Alaska from the Brooks Range north be protected as wilderness. He returns to Wiseman for 13 months (8/30–9/31) and makes keen observations on the happiness people enjoy "200 miles north of civilization."

1933

Robert Marshall's *Arctic Village* is published and becomes a best seller. H.L. Mencken reviews it and writes of the Wisemanites, "They have no politicians. Their police force is rudimentary and impotent. Above all, they are not cursed with theologians…They are free to be intelligent, and what is more, decent."

1934–1935

To create economic diversity and stability in Alaska, President Franklin Roosevelt's New Deal government invites 202 depression-stricken farming families from the upper Midwest to Alaska's Matanuska Valley. (The hardships are many; in a few years only 40 families remain. They eventually grow record crops, including 80-pound cabbages.)

1939–41

Wildlife biologist Adolf Murie studies predator-prey relationships (in Mount McKinley National Park) and shows the importance of wolves in a healthy ecosystem; his research helps to destroy the myth that wolves are random killers.

1940

Alaska's population is 72,000 (40,000 Natives; 32,000 whites). Fort Richardson and Elmendorf Air Force Base are established (near Anchorage).

1942

Japanese forces attack the Aleutian Islands; bomb Dutch Harbor, occupy Attu and Kiska Islands. The 1,522-mile Alaska–Canada Highway is constructed in nine months to strengthen U.S. defensibilities in Alaska. Early travelers on the bone-jarring, rock-flying gravel road ask, "Who's the lout who built this route?"

1943

Japanese forces are evicted from Alaska, but at a heavy cost of American lives: 549 dead, 3,280 injured. (Only one other battle in the Pacific campaign, Iwo Jima, costs more American lives in proportion to the number of troops involved.)

1946

For the first time in history Nome has more churches than saloons.

1947

Barbara Washburn becomes the first woman to reach the summit of Mount McKinley.

1953

Alaska's first oil well is drilled near Eureka; the first large-scale pulp mill opens in Ketchikan. In February, 24.8 feet of snow falls at Thompson Pass, near Valdez, a record one-month snowfall for Alaska.

1957

Kenai booms from an oil strike.

1958

An earthquake along the Fairweather Fault triggers a massive landslide in nearby Lituya Bay. A giant wave sloshes 1,720 feet up a mountainside, strips it of forest and soil and washes out the bay into the Gulf of Alaska.

1959

Alaska becomes the 49th State in the United States. William Egan becomes the first governor elected by popular vote. His son Dennis builds an amateur brewery in the basement of the Governor's Mansion; years later he is elected mayor of Juneau.

1960

After contentious debate in Congress, Secretary of the Interior Fred Seaton signs a public land order that creates the 8.9 million acre Arctic National Wildlife Range. (It is later promoted from "Range" to "Refuge," and doubled in size.)

1964

The strongest recorded earthquake in North America (magnitude 9.2; eighty times stronger than the 1906 San Francisco earthquake) hits Alaska on Good Friday, March 27. Anchorage is badly damaged as 131 people lose their lives (119 of them in a tsunami). Shorelines are destroyed and forests flooded in southcentral Alaska.

1966

The Alaska Federation of Natives is founded.

1967

Art Davidson, Dave Johnston, and Ray Genet complete the first successful winter ascent of Mount McKinley. While descending, a storm traps them for six days with a wind chill factor to −148°F. All three survive.

1968

Atlantic Richfield reports a "major discovery" 8,900 feet below the surface of the North Slope at Prudhoe Bay: an estimated 10 billion barrels of oil. (It becomes the largest oil field in North America; supplies the U.S. with 25 percent of its domestic oil, and frees Detroit to build wasteful but attractive cars and trucks that Americans love to drive). Alaska Governor Walter Hickel hails the "great news" and

without public hearings or permits slashes a road north that destroys tundra and permafrost and melts into a canal. John Strohmeyer, winner of the Pulitzer Prize, writes later,

> *The threat to Alaska's wilderness was growing larger than arrogant governors and Caterpillar skinners. The biggest names in the oil industry were readying to skim the riches of a land they didn't even know.*

1969

In one seven-hour auction, the State of Alaska collects 20 percent down on more than $900 million in oil and gas leases on the North Slope, less than one-thousandth of one percent (.001%) of its land area.

1970

Alaska's State Division of Parks is created, encompassing one of the largest and most diverse state park systems the United States. Japanese climber Naomi Uemura completes the first successful solo ascent of Mount McKinley. Alaska's population reaches 302,000; it will increase by 100,000 with the oil boom over the next ten years.

1971

Congress passes the Alaska Native Claims Settlement Act (ANCSA) that bequeaths 40 million acres and $962.5 million to Alaska's Natives (as compensation for their aboriginal claims to Alaska). To manage the land and money, 13 regional business corporations and 203 village corporations are established. Each Alaska Native is granted 100 shares in his or her corporation. (In time many corporations become extremely influential in Alaska politics and economics, as Natives struggle to marry traditional values with modern capitalism.)

1972

The George Parks Highway is completed between Anchorage and Fairbanks. Mount McKinley National Park introduces a shuttle bus system to reduce traffic and maintain wildlife along the park road.

1973

The first full-length Iditarod Trail Sled Dog Race is run from Anchorage to Nome. Winner Dick Willmarth finishes in 20 days and receives $12,000. (Twenty-five years later, winners finish in nine days—weather permitting —and receive $50,000.) Vice President Spiro Agnew casts the tie-breaking vote in the U.S. Senate to approve an "all-American" oil pipeline from Prudhoe Bay to Valdez. (Other proposals suggested a pipeline to Edmonton, Alberta.) Conservationists believe a pipeline terminus in Valdez will result in heavy tanker traffic and a major oil spill in Prince William Sound. Not to worry, say technocrats, industrialists, and politicians: it'll never happen.

1977

The 800-mile-long Trans-Alaska Oil Pipeline is completed over two mountain ranges and over (or under) 350 streams and rivers; the first shipments of North Slope crude depart Valdez.

1978

A 200-mile offshore fishing limit is established (to prevent foreign vessels from entering U.S. waters without a permit). Jimmy Carter signs a presidential proclamation that creates 17 new national monuments covering 56 million acres. Many don't-tread-on-me Alaskans decry it a "lock-up."

1979

The State of Alaska files suit against President Carter's proclamation (of 1978). Susan Butcher and Joe Redington (Father of the Iditarod Trail Sled Dog Race) mush sled dogs to the top of Mount McKinley.

1980

Alaska's population reaches 402,000. The State Legislature repeals the state income tax, refunds 1979 taxes, and establishes the Permanent Fund, a savings account from oil royalties (that in 15 years will exceed $20 billion). Congress passes the Alaska National Interest Lands Conservation Act (ANILCA), the "Louisiana Purchase of the American Conservation Movement" that gives protective status (as wilderness and national parks, preserves, monuments, and wildlife refuges) to more than 100 million acres. Mount McKinley National Park is enlarged and renamed Denali National Park & Preserve. Katmai and Glacier Bay National Monuments are enlarged and become National Parks & Preserves. Five other national monuments (established by President Carter in 1978) become national parks: Gates of the Arctic, Kobuk Valley, Kenai Fjords, Wrangell-St. Elias, and Lake Clark. Acreage in Alaska's National Wildlife Refuge System is increased nearly four-fold (to 77 million acres). Parts of 25 Alaska rivers are added to the Wild & Scenic Rivers System. Alaska Senator Ted Stevens fights ANILCA nearly every step of the way and adds language that permits aircraft landings in wilderness parks and giveaway clearcutting in the Tongass National Forest.

1981

Secretary of the Interior James "I-don't-like-to-hike" Watt announces his intentions to open 130 millions acres of Alaska (and 16 offshore areas) to oil and gas exploration. Alaskans greet him on the steps of the state capitol in Juneau with a twenty-one chainsaw salute.

1982

The Alaska Chilkat Bald Eagle Preserve is established near Haines. The first Permanent Fund Dividend checks ($1,000) are distributed to each Alaska resident, man, woman, and child.

1983

Edward Abbey visits Alaska and writes,

Alaska is not, as the license plates assert, the "Last Frontier." Alaska is the final big bite on the American table, where there is never enough to go around... For Americans, Alaska is the last pork chop.

1984

The first Yukon Quest International Sled Dog race is run between Fairbanks and Whitehorse, Yukon Territory (1,000 miles).

1985

By sneaking out of Shaktoolik in the middle of the night and braving a storm on frozen Norton Bay (and fortifying herself with seal oil and Norwegian chocolate), Libby Riddles becomes the first woman to win the Iditarod Trail Sled Dog Race. (Susan Butcher will win in 1986, '87, '88, and '90, and T-shirts will appear around the state: "Alaska, where men are men and women win the Iditarod.")

1988

Vern Tejas completes the first successful solo ascent of Mount McKinley in winter. He traverses glaciers with a long aluminum ladder straddled at his waist; in theory "Bridget" will prevent him from falling into a crevasse if a snow bridge collapses.

1989

On Good Friday, March 24, the supertanker *Exxon Valdez* runs aground on Bligh Reef and spills 11.3 million gallons of North Slope crude in Prince William Sound: the largest oil spill in U.S. history. More than 1,500 miles of pristine shoreline are despoiled by a toxic black tide. Among the known dead: 300 harbor seals, 2,800 sea otters, 250,000 birds, and 13 killer whales. Fisheries collapse. Communities sink into economic and spiritual depression. When asked went wrong, an oil executive responds, "It's simple. A ship hit a rock."

1990

Alaska's population grows to 550,000, with 50 percent in Anchorage. Overall state population density remains less than one person per square mile, but only for three more years. (Alaska's land area is 586,412 square miles, or 365 million acres: one million acres for each day of the year). Congress passes the Tongass Timber Reform Act to stop irresponsible logging in the nation's largest national forest. It improves but does not remedy the situation. Walter Hickel becomes governor for the second time (this time as an independent). He champions an Alaska of more roads and fewer wolves.

1991

Rick Swenson wins the Iditarod Trail Sled Dog Race for the fifth time, the only musher with that many victories.

1993

An EXXON-funded study concludes there is no significant long-term damage to shorelines in Prince William Sound.

1994

EXXON pays more than $300 million in compensation to Alaska Natives and commercial fisherfolk in Prince William Sound and southcentral Alaska. A federal jury finds EXXON guilty of recklessness and orders them to pay $5 billion in punitive damages. EXXON appeals.

A "Republican Revolution" sweeps Congress and gives Alaska unprecedented political power as Senator Frank Murkowski and Representative Don Young gain chairmanships of natural resource committees, and Ted Stevens later becomes chairman of Senate Appropriations. Among their objectives: rewrite the Endangered Species Act to give more protection to businesses and less to wildlife, increase cruise ship traffic by 72 percent in Glacier Bay, build another road (or a railroad) through Denali National Park, eliminate U.S. participation in the World Heritage Site and Biosphere Reserve Programs, convert the Tongass National Forest into a state forest (thereby more accessible for clearcutting), and open caribou breeding grounds in the Arctic National Wildlife Refuge to industrial oil drilling.

1998

Russian climbers reach the summit of Mount McKinley in January, the first ascent in the middle of winter. Margaret E. Murie, 95-year-old conservationist, co-founder of The Wilderness Society (1935) and the first woman to graduate from the Univeristy of Alaska (1922), receives the Presidential Medal of Freedom.

❧

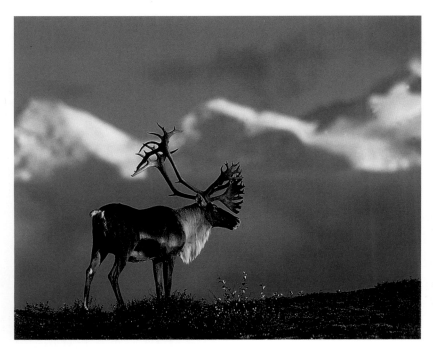

PHOTOGRAPHER'S NOTES

I believe every book begins in debt: every photographer who produces one burns a lot of film and gas, consumes large volumes of paper and ink, and partakes of warm hospitality and friendly hot meals. Especially in Alaska. Alaska is a big state but a small town. People have their differences, but they look out for each other. I thank everyone who helped me along the way. You are too many to list, and I fear some would be missed if I attempted, so allow me to find you again in person, because I cannot fax a handshake or e-mail a smile. I only hope that in the final analysis, if there is such a thing, *Alaska Light* contributes in a positive way to the future of your wild home.

Every animal photographed in Alaska Light is in the wild, except one: the injured northern barred owl on page 87. He lives at the Alaska Raptor Rehabilitation Center in Sitka, with injuries too severe to allow him to fly free. So he perches on a railing of a wooden deck and serves as an ambassador between birds and people. No photograph in this book has been digitally enhanced or composed. A few scenes were altered by hand in the field: the feather in paintbrush on page 1 was found where you see it, but rotated ninety degrees; the caribou antlers on page 8 were moved slightly. Chilkat Dancer Charles Jimmie, Sr., on page 22, repeated several steps for me and explained the history behind them. The black oystercatcher on page 44 is from the Falkland Islands. I had opportunities to photograph these birds in Alaska, but felt this shot was strong enough; besides, the birds have families to raise, and few wild critters can be photographed without the photographer intruding into their lives. The running caribou on page 80 were spooked when a nearby hunter fired his rifle. The sandpipers on page 81 took flight on their own. I had opportunities to photograph wolves and ravens, but did not. It felt good to defer to their power and mystery. The people on pages 29, 34, 39, 48, 55, 59, and 104 are posed.

For landscape, lifestyle, and vegetation shots I used Mamiya 645cm cameras with 45mm, 80mm, 110mm, or 210 lenses. For wildlife I used a Nikon F4 camera with 300mm or 500mm lenses, and a 1.4x teleconverter. But mostly I used my heart and head. My preferred film was Fujichrome Velvia. Some images were enhanced with polarizing, warming, and/or graduated neutral density filters. Pallas PhotoImaging processed the film in Denver, Colorado.

Kathy Bushue, a professional photographer from Anchorage, took the polar bear and sockeye salmon photos on pages 97 and 102. Ken Graham, who owns his own stock photography agency in Girdwood, with his wife, Jacky, took the aurora and oil spill photos on pages 23, 46 and 47.

Thank you one and all! Your light is my illumination.

❧Kim Heacox